INVENTORY 1985

RODCHENKO
PHOTOGRAPHY

RODCHENKO PHOTOGRAPHY

Alexander Lavrentjev

Rizzoli
NEW YORK

Translated from the German
by John William Gabriel

Copyright © 1982 Schirmer/Mosel GmbH, Munich

Published in the United States of America in 1982 by
RIZZOLI INTERNATIONAL PUBLICATIONS, INC.,
712 Fifth Avenue, New York, NY 10019

LC: 82-60031
ISBN: 0-8478-0459-3

Printed and bound in West Germany

CONTENTS

"You run across revelations every day; only the eye must learn to see them without bias or preconception."

Man Ray

A New Way of Seeing the World[1]

The selection of photographs published here appears for the first time in the present form. Some of the photographs were printed during Alexander Rodchenko's lifetime in *Novii LEF, Sovetskoe kino, Sovetskoe foto, Daes* and other periodicals.

Besides his work in design and graphic art, Rodchenko was much occupied with photography at the end of the twenties. While arranging his photographic archives it occured to him to put together those prints of his that had been published up to then, documenting his contribution to the field, which he knew to be historic. The resulting collection—a series of cropped prints mounted on uniform sheets of heavy brown paper—was a unique monograph on his own work; and the subject of this unpublished book of published photographs was the beauty of the industrial world, a beauty he spent his life trying to help people see. Keeping in close touch with every new advance in photographic art outside Russia, Rodchenko saw his task as one of continual improvement and discovery: "I have created today," he said, "in order to seek what is new tomorrow, even if it should prove nothing in comparison to the past; all the same, tomorrow I shall improve on the present."[2]

To Rodchenko's own selection we have added several previously unpublished photographs in order to show the context in which one or another key image was made. This has given rise to a number of comprehensive series that prove Rodchenko was a master of reportage—an unusual sort of reportage, since its subjects were not so much the ever-changing faces and gestures of human beings but the seemingly impassionate aspects of things like machines, buildings and construction sites.

In 1925 or 1926 Rodchenko added some new books to his library of photography, among them Erich Mendelsohn's photographic essay on New York[3] and the German edition of Moholy-Nagy's *Painting, Photography and Film,*[4] the new Russian edition of which did not appear until 1929.[5] From publications like these he selected images for the column entitled "Photography in Cinema" which he edited for the magazine *Sovetskoe kino* from 1926 to 1929. The photographs he found there also convinced him that, as he had said as early as 1921, "we must learn to understand modern industrial reality inside and out."[6] Mendelsohn and Moholy-Nagy often used extreme perspectives in their photographs of the man-made world, and their approach fascinated Rodchenko mainly because they were not professional photographers but architects, designers or artists who used the camera as one tool among others, men who were involved in shaping a

9

new environment. In the stark foreshortenings of their photographs Rodchenko recognized a perfect means to reveal the astonishing beauty of industry:

To answer how Rodchenko became involved in photography, since he trained as a painter[7], we have to go back to 1923, when he first began using photomontage for poster design, newspaper advertising, illustrations and book jackets. The material for these montages was originally taken from newspapers and magazines, but not always being able to find the right subjects or the right size photograph, Rodchenko soon began to do his own printing and enlarging. Throughout his career we find many such examples of his practical bent. To him photography was an applied art in the service of production, as he put it; and production included, when the case demanded, mixed media.

A man in dark glasses, his collar turned up . . . a woman sprawling on the ground . . . next to her, a gigantic knife . . . and the indefatigable secret service man pointing his finger at the culprit . . . A sequence from some crime movie? No, only a photomontage, made up of pictures taken by Rodchenko in 1924 of himself, his wife the painter Varvara Stepanova, and his friend Vitalii Zhemchuzhyi a film director. Such montages of his friends and relations appeared regularly on the covers of *Mess Mend,* a serialized novel by Marietta Shaginian, who wrote under the hard-boiled pen name of Jim Dollar. The pose, composition, and predominance of a strong, single light source in Rodchenko's first commerical photographs have much in common with the cinematography of the day.

The drama of the situations underlined the suspense-packed plot of Shaginian's novel. These were among the first photographs Rodchenko ever took.

Modern applied photography can follow one of two basically different courses: either the subject can be taken under natural conditions, on the spot; or a shot can be set up in the studio, where the conditions—atmosphere, background—are under the complete control of the photographer. In the first case the photographer needs a reporter's quick reactions and a artist's inventive eye. Rodchenko had both, as we can see from the still lifes of machines he took for his article on the AMO factory—not a single negative was wasted. This calls to mind the advice he gave his students during the *Soyuz* photo courses he taught in the thirties: "Think before you shoot, while you shoot, and after you shoot!"[8]. Today's sophisticated equipment enables the scientific or technical photographer to take his camera to the subject, of which Rodchenko could only dream.[9] The greatest advantage of on-the-spot photography, in his eyes, was its documentary character.

Studio photography, by contrast, had a very

different purpose to fulfill. Once, while arranging the stage props for a film called *The Girl Reporter,* he spoke of his prime task as demonstrating convincingly, on the screen, the conventions of cinema: "What you have to achieve is to make everything that is actually posed look real."[10]

I have mentioned Rodchenko's talent as an arranger of images in connection with his designs for the covers of *Mess Mend.* Another example of an even tighter interweave of photograph and text is his poster *Knigi* (Books), done for the *Lengiz* in 1925.[11] Here, using a three-quarter profile of Lilia Brik (taken expressly for this composition) and some striking typography, he managed to materialize the spoken word. Asked to explain his reasons for using photography in posters, which was still the exception, Rodchenko replied that he did it "For real life, for the true human being, and true human beings can be portrayed only in a photographic poster, in which realistic photography alone can provide a new and authentic reflection of life."[12]

Peculiarly static and austerely photographed by contrast is the hand holding the instrument on the cover of *The Journalist* for 1929. On the back cover of the same issue we see another composition, this time with the attributes of modern man par excellence, the reporter—a Leica camera, a pen and a notebook. "The camera lens is the eye of civilized man in a so-cialist society."[13] These words might serve as a motto for the composition just described. It is a still life made up of objects that the artist himself used throughout his career. The prototypes for this scene were doubtlessly the pictures of his worktable which he took in 1926, and called *Table in Disarray.* Rodchenko was always fascinated by the orderly disorder of an artist's tools, which is probably just as individual as a human face.

Many of the master photographers of the twenties were either professional designers or strove for a similar synthesis of form within the photographic art. Rodchenko was no exception. At the International Exhibition of Decorative Art in Paris in 1925, he did not participate as a photographer; he still considered himself a beginner in the field, and exhibited only his photomontage illustrations to Mayakovsky's poem, *Pro eto* (About This). The technique of these pictures was absolutely congenial with the text, whose verses might be described as metaphors in motion. Mayakovsky confronts everyday objects presented from uncommon and unexpected points of view; Rodchenko's montages are likewise metaphors, visual ones that are based on a similar principle of composition. In one of them he combines mundane objects of various sizes, views of architecture and portraits of Mayakovsky and Lilia Brik taken for the purpose by A.P. Sterenberg, the fine portrait photographer.

His work on photomontages for *Pro eto* led Rodchenko into taking, in 1924, what were to remain his best portraits of Mayakovsky. His serious work in the photographic medium can be dated from that year. Even his first portraits—that of his mother and the double exposure of the painter Aleksander Shevshenko—are striking in their classic simplicity.

While in Paris for the exhibition, Rodchenko directed his camera mostly at architectural subjects, including the interior of the Worker's Club which he himself had designed as part of the Soviet contribution. At the time still a rare form of public amenity, this club won Rodchenko a silver medal. The photographs he took in Paris are particularly interesting because they show him consciously employing his characteristic forced perspective for the first time. He not only photographed the Worker's Club in this manner but the Soviet pavilion as well. The pure clear volumes of this structure, designed by Konstantin Melnikov, must have impressed the visitors to the exhibition as being quite astonishingly unlike the pompous, complexly ornamented pavilions of other nations. Melnikov's building stood for a new architectural aesthetic of pure geometric form, smooth expanses of glass, and above all an exposed load-bearing skeleton.

To those schooled in traditional architecture and used to judging a building mainly by its facade, the constructivist approach must have seemed arid. Only very gradually did a new way of seeing architecture develop, an ability to appreciate cogent details and exciting perspectives. To have contributed substantially to this modern viewpoint is one of Rodchenko's achievements. It is interesting to consult the list of criteria he drew up in the late thirties for an educational documentary entitled *Moscow's Modern Construction.* He himself blocked out the shots for this film, and his work behind the camera was conceived as follows: "On the scene we have to emphasize the grandeur and modernity of the buildings; their architectural pathos must emerge, lightened by views of our new life (the zoo, moving into a new house, sports events, playgrounds, etc.). All the immobile facades must be made to unfold dynamically before the audience's eyes."[14]

In the Fall of 1925, with what at the time was a small-format camera, an ICA he had brought with him from Paris, Rodchenko made a series of pictures of his Moscow house, on Myasnicka Street. The poet Nicolai Aseev lived in the same building and, like Rodchenko, on the eighth floor. This is his description of his neighbor's photo sequence: "Here we have the building from below, obliquely. It recedes, shrinks in perspective. Here it is falling, disintegrating, crushed under the weight of its own walls. Here again, as it violently shoots downwards with all its nine balconies, which get gradually smaller because they have been photographed from above. This is a new way of

seeing, to mankind a new and hitherto unknown possibility to see objects in their exact perspectives, which overthrow every notion of proportion and relation. [This new vision] sharpens a perceptive capacity grown blunt and dulled by the habitual view of things (static, always from the same standpoint)."[15]

The fact that Rodchenko made not one or two photographs but entire series of each subject he chose, is a key characteristic of his work. What we see illustrated in his photographs, if you will, is an artistic program, a complex problem that can be solved only by attacking it from many angles. That is why it is so difficult to select any one image as representative of a series, his *House on Myasnicka Street* for example. Each image exists as part of a larger whole, a unity that is destroyed as soon as one fragment is split off from it and isolated.

In many of the undated prints, we have not had much difficulty in assembling series based on similarities in lighting and subject, and, thus, in reconstructing the themes and coherence of the images. These sequences reveal their author's scenario, which though he may not have written it down in advance, must certainly have been composed in his mind before he picked up his camera.

Working on the beautiful sequence called *Glass* (1928) for instance, Rodchenko's conception will probably have been something like "still lifes of glass objects photographed with back lighting." We see an everyday glass jug filled with water, and an open book, exposed from every possible angle—the water distorts the printed page, refracting it like a lens, and the common jug is transformed into a crystal ball suddenly capable of poetically transcending its real existence. Glass is a material that proves fascinatingly versatile in Rodchenko's hands—full of delicate halftones or stark graphics, glossy or rough textures, transparent or opaque. The artist's camera fixes each stage of the eye's approach to the object: first on a conventional and familiar scale that only reduces the object in size; then a detail is picked out, enlarged, its play of reflections giving the material a jewel-like preciousness; and finally Rodchenko takes us deep into the substance of the glass itself, shows us the rhythmic lineaments of its tiniest details, revealing its beauty—and its industrial origin. While doing this sequence Rodchenko experimented by placing his glass objects on a glass 9x12 negative and exposing them. Though he developed this negative, he sadly never attempted to take a print from it. "Such experiments," he wrote, "make it possible for us to change the traditional way we look at the common objects that surround us."[16]

Rodchenko published a selection from his *Glass* sequence in 1928, in *Novii LEF,* No. 3, thereby tremendously enriching the pictorial language of his day. His technique is now employed as a matter of course when photo-

graphing transparent objects, since the properties of such objects can be revealed exhaustively in this manner.

A sequence of photographs can also capture the phases of a movement, and thus record an event in time—this or a related thought may have led to the idea of combining photographs with the printed book, which opens out page by page before the reader's eyes. In 1926, Rodchenko and Stepanova began to experiment with illustrations for a children's book called *Samozveri* (Do-it-yourself Animals) with verses by Sergei Tretiakov.[17] They made animals out of cardboard which initially were to be detachable from the book, so that children could play with them and invent their own variations on the story. However, the sequence changed in the course of Rodchenko and Stepanova's work from still photographs to multi-aspect images.

Tretiakov's verses evoke the imaginative role-playing that children are so good at. The little boy in his story dresses up as an ostrich, then transforms himself into a horse, then into various other animals. Hence the book's title—*Do-it-yourself Animals.* Its cut-out figures, all constructed of a few basic shapes, act out the story in a unique visual parallel, and the dark background heightens the illusion of reality, of a real, three-dimensional room like that described in the poems. "It is generally assumed that composition is only a matter of distributing figures and objects on the picture plane," Rod-

chenko writes, "this is not so. Composition is all of that plus the particular structure of each figure, plus light and tonality—the overall effects of light and the overall tonality; yet an entire composition can even be built up on light or on tonality alone."[18]

Rodchenko's do-it-yourself animals are composed of planes and hollow cylinders; in the photographs the planes appear in sharp contrast of light and dark, while the cylinders have soft gradual transitions. Each figure has been photographed from the angle that brings its sculptural qualities into sharpest relief.

Rodchenko's early photographs represent an attempt to synthesize the three arts of literature, design and photography. His double exposures of some subjects create the impression of movement through time, a literary prerogative not attainable by normal photographic methods. In one image sizes may be jumbled, and large-scale objects appear next to small; in the next, the camera may have caught one and the same motif, but from two entirely different angles. The ratio of these views is about 1:2. In his early period we find Rodchenko returning again and again to an Iochim 9x12 camera with a 6.3 Bertiot lens, using it for portraits, still lifes and architectural subjects alike.

His photographs of Briansk station and the Sovkino premises are offshoots of film work, made while acting as art consultant to B. Barnet, who directed *Moscow in October,* and

to L. Kuleshov in his work on *The Girl Reporter.* A creative adjunct of his cooperation on the former film was a series of cityscapes and photographs of single buildings. By roaming the Moscow streets in search of good locations for outdoor shots, Rodchenko rediscovered his city. He photographed the endless depths of the Moskva plain and, as background for the October rising, corners of the city as yet untouched by renewal. Nor was he indifferent to the life around him. He began to diversify his interests, turning his camera on urban situations and scenes and the signs of modern technology all around him. For Rodchenko, technology symbolized social transformation, and one such symbol of a bright industrial future, the station at Briansk, inspired him to tell its story in pictures.

He shows us the station interior with its waiting trains from a dramatic bird's-eye view. Then we see images filled with strange and, at first sight, incomprehensible webs; on closer examination, these turn out to be parts of the station's iron structure, elements repeated over and over that recede sharply foreshortened into infinity. This time the perspective is low-angle. Finally, we see the cameraman and director of *Moscow in October* balanced on the roof of the building, shooting a scene, a photograph that makes it clear that Rodchenko took his pictures during breaks from the filming.

In 1928, Rodchenko bought himself a Leica.

From then on, he could be seen combing the city streets for subjects. This was the period of the first Five Year Plan. To give an idea of his creative aims at the time, it is enough to quote the captions he attached to his negatives. The titles are listed here just as he wrote them on the envelopes:

"1928—Telephone exchange. The Krasnii-Proletarii Factory. Pipe in Petrovsky Park. Loudspeaker and flags. Street ad. Bus facility at Bachmetiev, designed by the architect K. Melnikov.

"1929—Power plant. The AMO works. Radio Center. Experimental transmitter. Children's home. Ramenskoe. Gasoline pump. Antennas on roofs. Display window. Glass factory. Shuchov Tower.

"1930—Planetarium. Bus. Clockwork. Mosenergo. Kiosk. Work beginning on the subway. New buildings on Sucharevka Street. Shabolovka. Public kitchen. New telegraph. Ball bearing. Public library. The founder of letterpress, Ivan Fedorov. Myasnickii Gate. Movement."

This list could be extended, and it would form a literary work of a special kind, since these dry titles, written by hand, express Rodchenko's personal attitude to the subjects portrayed. The

appearance of stylistically unprecedented things in the Moscow streets—advertising signs, newsstands with their book and magazine covers, auto repair shops and workers' clubs—interested Rodchenko as a constructivist artist and as a teacher, who at the end of the twenties graduated the first class of professional designers ever trained in the U.S.S.R.

His concern was to record how the new architecture and machines penetrated and transformed the old structure of the city. To explain his point of view to the young photojournalists he trained during the thirties, he would ask: "What sort of thing would you take pictures of?" then answer, "There are certain standard subjects, like paving a road with asphalt or concrete—but what about all those muddy streets a car could never get through and those completely impassable roads? Since we cannot look at everything at once, we have to photograph either the worst or the best, but never the average because that will not get us anywhere. You ought to take pictures of crews laying asphalt—that shows what we have to fight for."[19]

When phrases like New Architecture, New Life-style or New Technology crop up, it is good to recall the frame of reference in which the photographs of these new things were taken. Out of the countless possible situations, Rodchenko picked those that emphasized the contrast between old and new, as exemplified by his titles: *New Mogos* and *Old Moscow*. Such urban themes as itinerant merchants, sweet shops, the display window of a private photographer which still looked much the same as before the revolution, the window of a NEP outlet—Rodchenko recorded all these fragments of the scene as representing that passing order against which he, as a constructivist, fought. The outmoded activities he mercilessly captured in these photographs must be seen not only in terms of their significance for Rodchenko's stance but for the way in which they illustrate, by dramatic contrast, the achievements of a young and hopeful society.

Yet Rodchenko did more than document the obvious and outward changes in the urban scene, from the gigantic Shuchov Tower to the fine details of an automobile. He also photographed daily life in the student dormitories, Culture Parks and factory kitchens. During this period he began using the exaggerated perspective angle to photograph crowds demonstrating in the streets, and the close-up for portraits of his contemporaries. And, for the first time, he employed a trick of composition that expressed perfectly the dynamic mood of the day—the tilted horizon line, something unheard of in traditional photography.

Almost all of the images he made with the Leica were published uncropped; he seldom had to repeat an exposure, so sure had he become of his means and so carefully were his shots planned. Once someone asked him whether du-

plicates existed of his Mayakovsky portrait, and was shocked to hear that none did. Six 9"x12" negatives are in existence; a seventh plate was broken, but Rodchenko made a reproduction from the print. Thus there are seven portraits of the poet by Rodchenko, each a different composition and mood. The first of these to be published was the photograph showing Mayakovsky full-figure, in coat and hat. It was used in the montage for the cover of his *Conversations with a Tax Collector about Poetry*. None of the other portraits were published until after Mayakovsky's death.

From about 1932 to 1938, sports events and the circus were among Rodchenko's favorite subjects, and not only for his camera. Photographs, sketches, prints and paintings of the time abound with horses, acrobats, wrestlers and—how could it be otherwise—clowns. The clown, melancholic perfect actor, is center ring. This is the period in which Rodchenko painted one of his very few self-portraits: it shows his face made up like a clown's. The big top appears in Rodchenko's paintings in endless nuances of color that evoke one of the prime magic qualities of the circus—lighting. The same effects are gained in his photographs by graduations of only the two colors, black and white. The spotlight picks out the performers, makes them shine against a black background deep as the night sky, and the faces of the audience shine more dimly behind them like stars.

Circus and sports might seem to have little in common with machines and industry. Yet these photographs record the human beings who built the machines, typical people of the twenties and thirties, and as susceptible to the beauty of what they built as Rodchenko himself was. What fascinated him about sports and the circus was physical liberation, full reliance on the body's powers, tense equilibrium—whether in the syncopated rhythms of the circus acts or the strict geometry of group movement. Rhythms were Rodchenko's means of structuring the formless expanse of Red Square, the rhythms of mass calisthenics as much as those of a single graceful human body. Almost every picture in his sequence *Rhythmic Gymnastics* was taken from one fixed point. Before his lens, the movements crystallized into separate moments, fascinatingly captured close-up against a diminutively scaled background which in turn merges into a web of tonal gradations.

Rodchenko's photographs do not age, probably thanks to his ability to see the reality of his times and to capture that reality with the love of innovation so characteristic of him. His photographs reveal not only his own artistic mastery and his personal penchant for life's essential details but they also transmit the attitude of the society of which he was a part, every aspect of which he illustrated.

In the late thirties Rodchenko wrote his autobiography. Entitled *Black and White,* it reads like

a fairy-tale for adults. In the same way, he was able to render visible the beauty of the industrial world because he saw it through a poet's eyes. *Black and White* is also an essay on the creative imagination, and how absolutely necessary it is to every artist.

Looking at his photographs, his paintings, prints and drawings, it becomes obvious that Rodchenko loved the color black—those deep, silky blacks are everywhere. Not because he had a melancholy turn of mind, not at all. He was always full of little tricks and jokes, and they were irresistably funny. For him the color black was what you might call a poetic metaphor that stood for the unrecognized, the undiscovered . . . and you have to admit, black swans and black water shot through with glittering ripples—these are beautiful things.

NOTES

1. The title of an article by Nikolai Aseev, which appeared in the newspaper *Vechernaia Moskva,* No. 182, August 2, 1928

2. A.M. Rodchenko, *All Experiences,* manuscript in the collection of V.A. Rodchenko

3. Erich Mendelsohn, *Amerika,* Rudolf Mosse Buchverlag, Berlin, 1926

4. L. Moholy-Nagy, *Malerei, Fotografie, Film,* Albert Langen Verlag, Munich, 1925

5. L. Moholy-Nagy, *Painting or Photography,* Ogonek, Moscow, 1929

6. "Materials of the Institute for Artistic Culture," manuscript, collection V.A. Rodchenko

7. Rodchenko studied at the Kazan Art Academy from 1911 to 1914. He took his degree as a painter, showing his work from 1913 at various exhibitions.

8. "Fragments of a Lecture on Photography," manuscript, collection V.A. Rodchenko

9. A.M. Rodchenko, "Paths of Modern Photography," *Novii LEF,* No. 9, 1928

10. "The Artists and the 'Material Environment' in Motion Pictures. Conversation with the Artist A.M. Rodchenko," *Sovetskoe kino,* No. 5-6, 1927

11. Leningrad State Publishing House

12. A.M. Rodchenko, "Subdepartment for Photo-posters," manuscript, collection V.A. Rodchenko

13. A.M. Rodchenko, "On the Photos in this Issue," *Novii LEF,* No. 3, 1928

14. A.M. Rodchenko, "Stipulations for the film *Modern Construction in Moscow,* at MezhRabPom-Rus," manuscript, collection V.A. Rodchenko

15. N.N. Aseev, "From the Eighth Floor. A New Way of Seeing the World," *Vechernaia Moskva,* No. 182, August 2, 1928

16. A.M. Rodchenko, "On the Photos in this Issue," *Novii LEF,* No. 3, 1928

17. *Samozveri* by Sergei Tretiakov was never published. It has since however been reconstructed and brought out by W. Fütterer and H. Gassner, Cologne, 1980

18. A.M. Rodchenko, "Composition," manuscript, collection V.A. Rodchenko

19. A.M. Rodchenko, "Fragments of a Lecture on Photography," manuscript, collection V.A. Rodchenko

LIST OF ILLUSTRATIONS

The Photographs

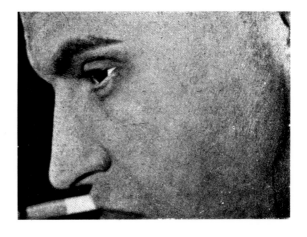

Selbstportrait 1
Selfportrait
Autoportrait

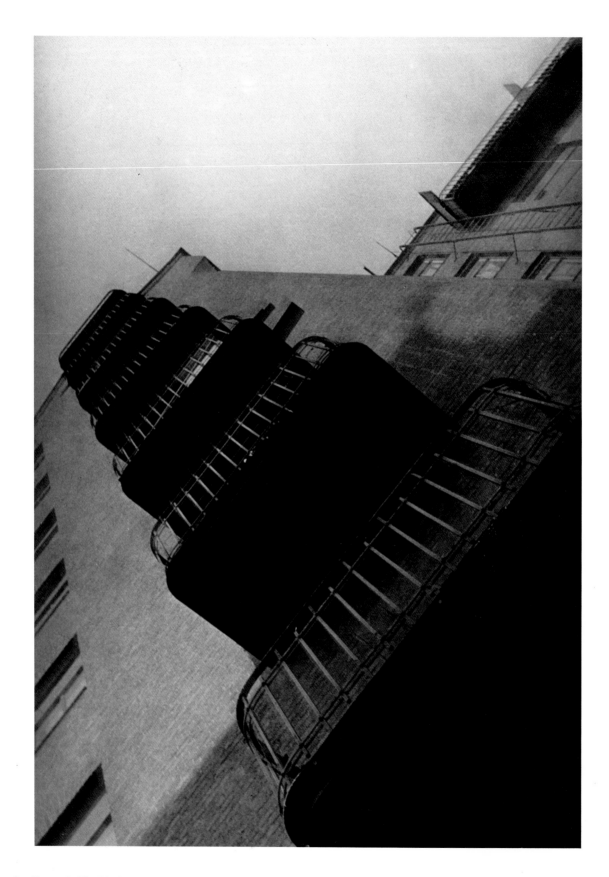

2 Haus an der Mjasnicka-Straße, 1924
House on Myasnicka-Street, 1924
Maison rue Mjasnicka, 1924

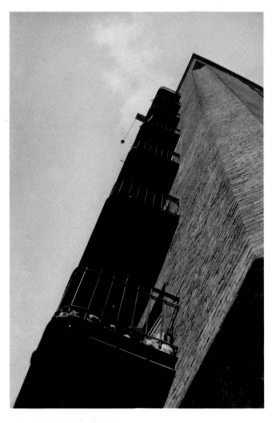

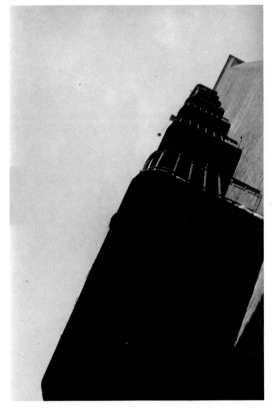

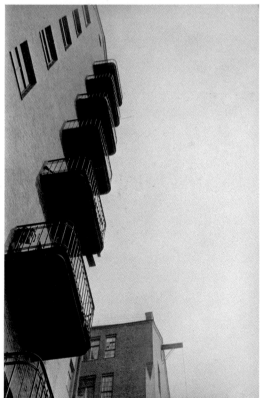

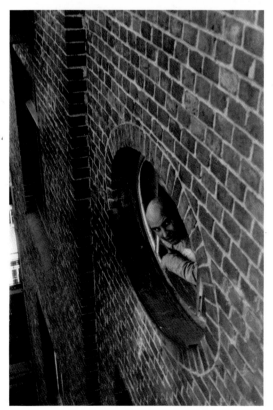

3–5 Drei Ansichten des Hauses an der Mjasnicka-Straße, 1925 V.L. Žemčužnyj: Portrait A.M. Rodčenko, 1925 6
 Three views of the house on Myasnicka-Street, 1925 V.L. Žemchuzhnii: Portrait of A.M. Rodchenko, 1925
 Trois vues de la maison rue Mjasnicka, 1925 V.L. Žemčužnyj: Portrait A.M. Rodčenko, 1925

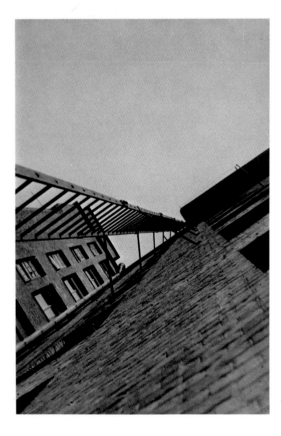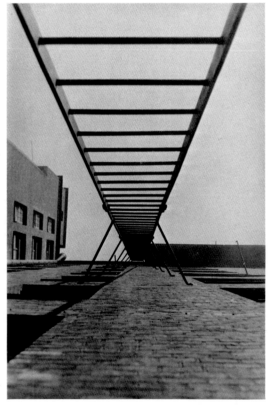

7–8 Zwei Ansichten des Hauses an der Mjasnicka-Straße, 1925
Two views of the house on Myasnicka-Street, 1925
Deux vues de la maison rue Mjasnicka, 1925

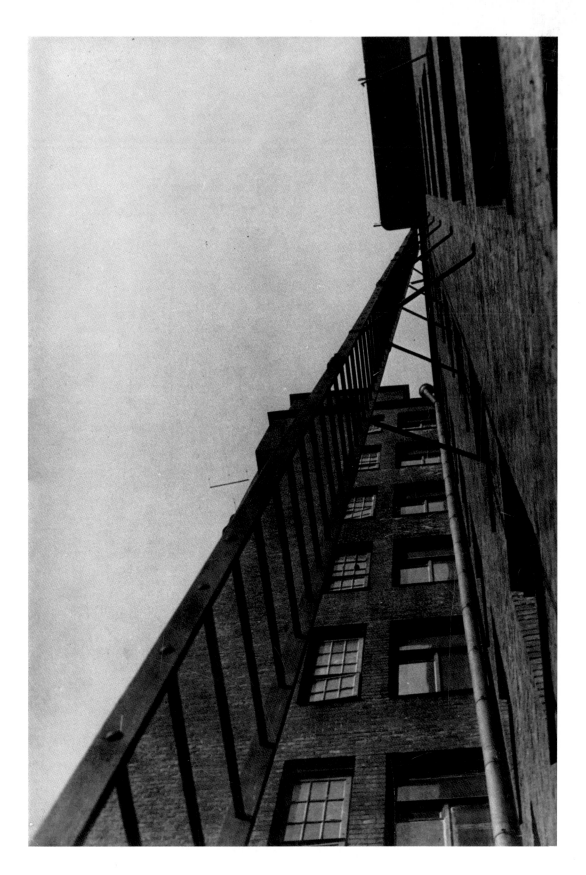

9 Haus an der Mjasnicka-Straße, 1925
House on Myasnicka-Street, 1925
Maison rue Mjasnicka, 1925

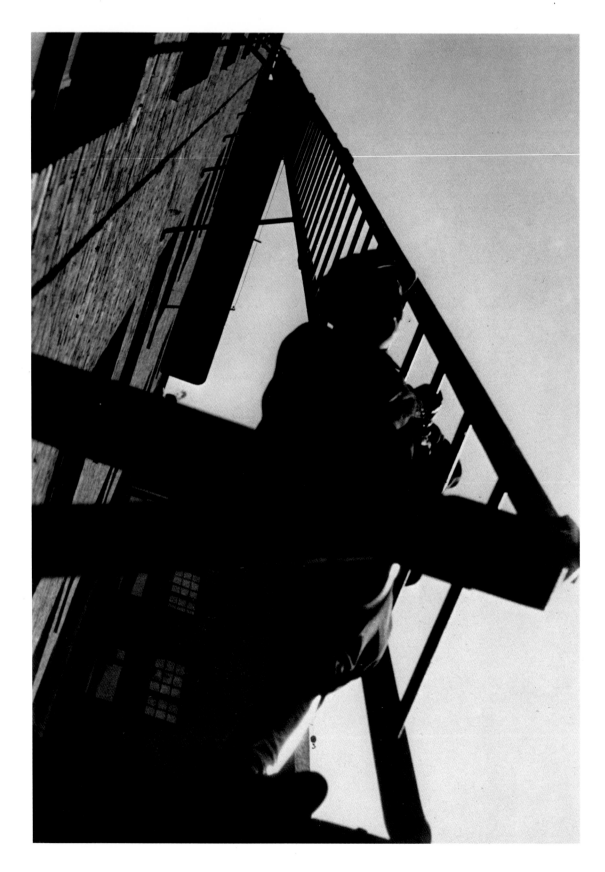

10 Haus an der Mjasnicka-Straße, 1925
House on Myasnicka-Street, 1925
Maison rue Mjasnicka, 1925

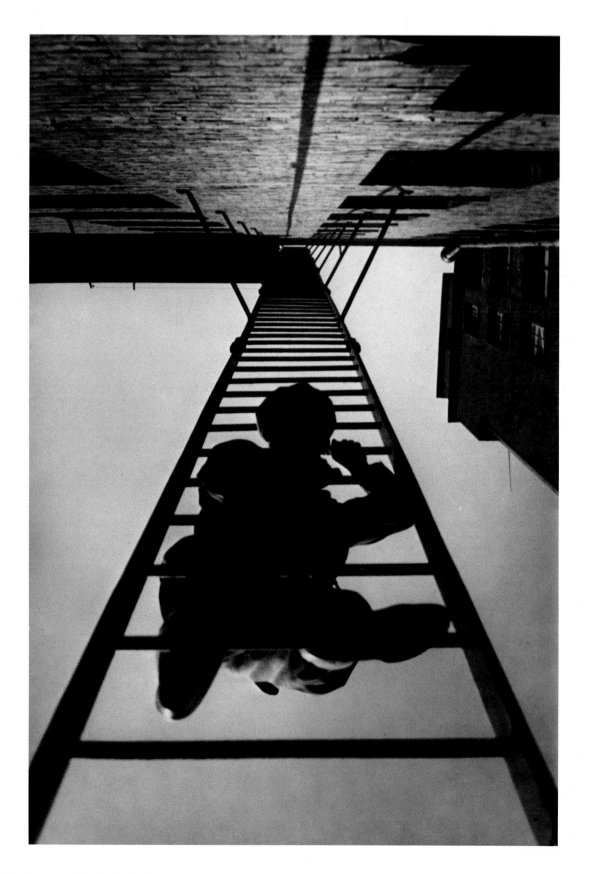

11 Haus an der Mjasnicka-Straße, 1925
House on Myasnicka-Street, 1925
Maison rue Mjasnicka, 1925

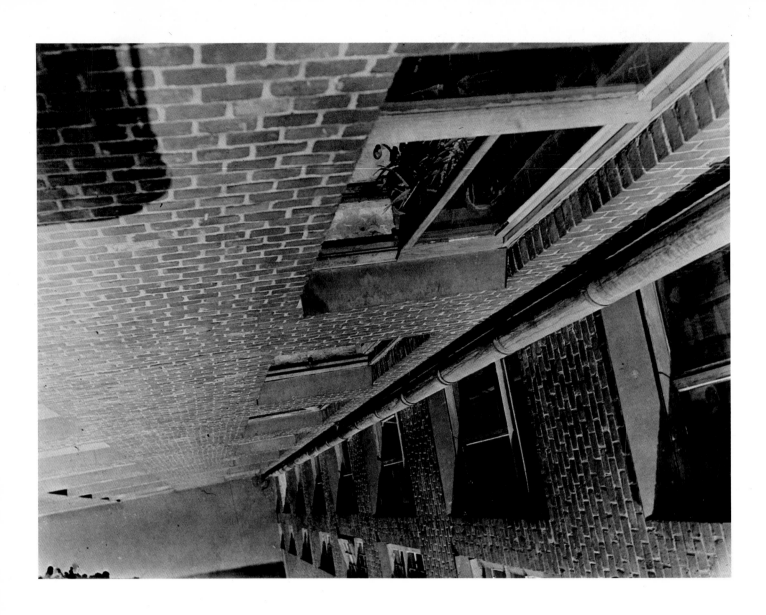

12 Haus an der Mjasnicka-Straße, 1925
House on Myasnicka-Street, 1925
Maison rue Mjasnicka, 1925

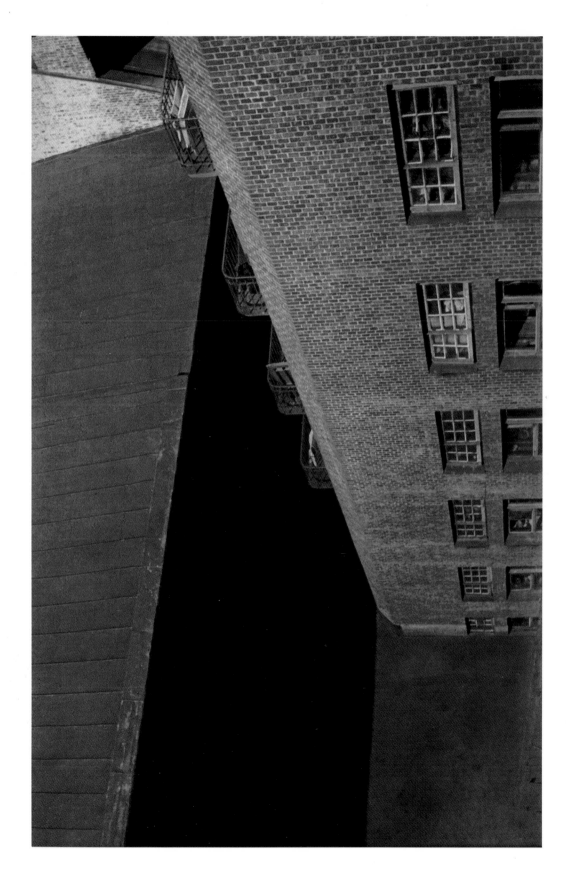

13 Haus an der Mjasnicka-Straße, 1925
 House on Myasnicka-Street, 1925
 Maison rue Mjasnicka, 1925

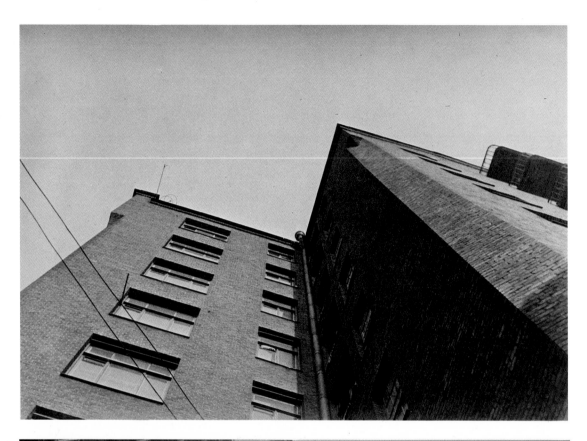

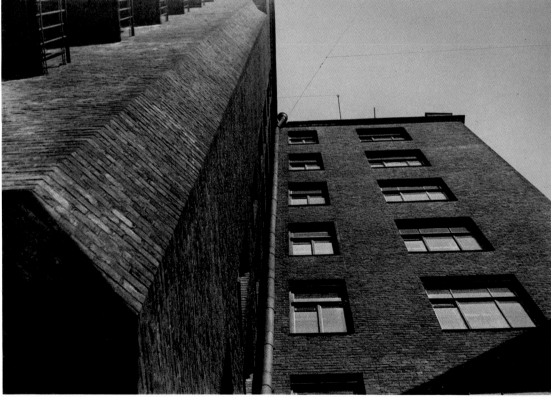

14–15 Zwei Ansichten des Hauses an der Mjasnicka-Straße, 1925
Two views of the house on Myasnicka-Street, 1925
Deux vues de la maison rue Mjasnicka, 1925

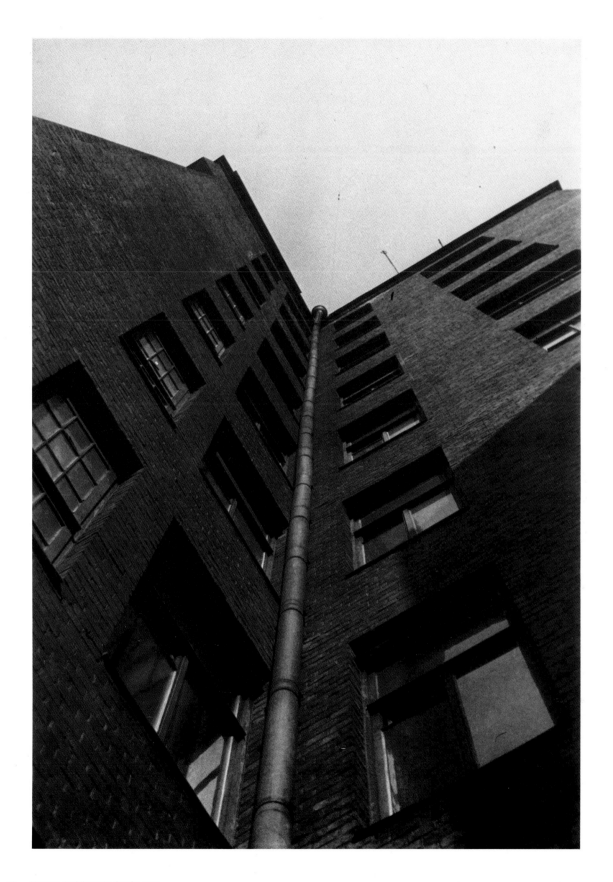

16 Haus an der Mjasnicka-Straße, 1925
House on Myasnicka-Street, 1925
Maison rue Mjasnicka, 1925

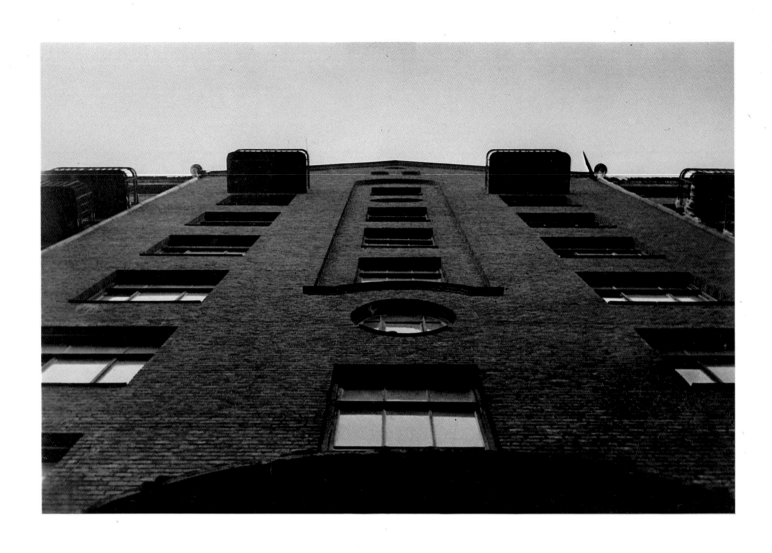

17 Haus an der Mjasnicka-Straße, 1925
 House on Myasnicka-Street, 1925
 Maison rue Mjasnicka, 1925

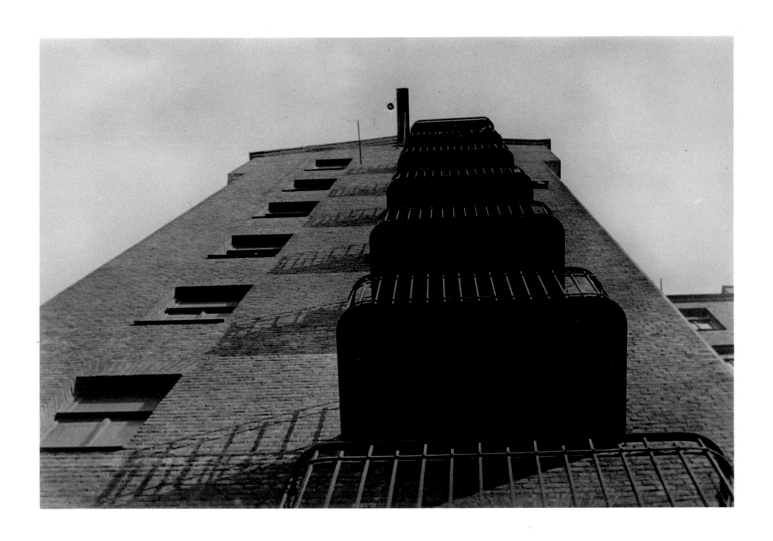

18 Haus an der Mjsanicka-Straße, 1925
 House on Myasnicka-Street, 1925
 Maison rue Mjasnicka, 1925

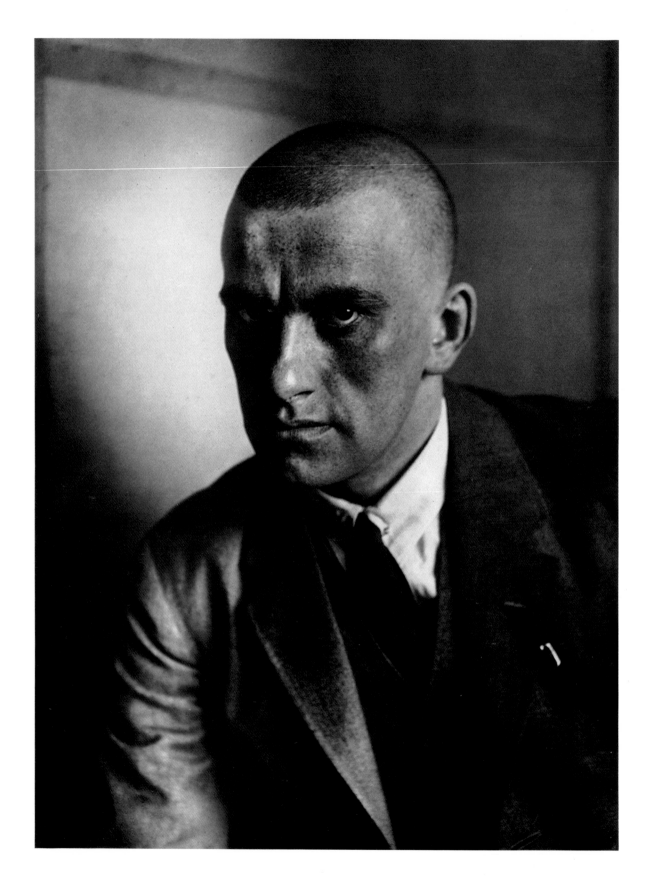

19 Portrait Vladimir Majakovskij, 1924
Portrait of Vladimir Mayakovsky, 1924
Portrait de Vladimir Majakovskij, 1924

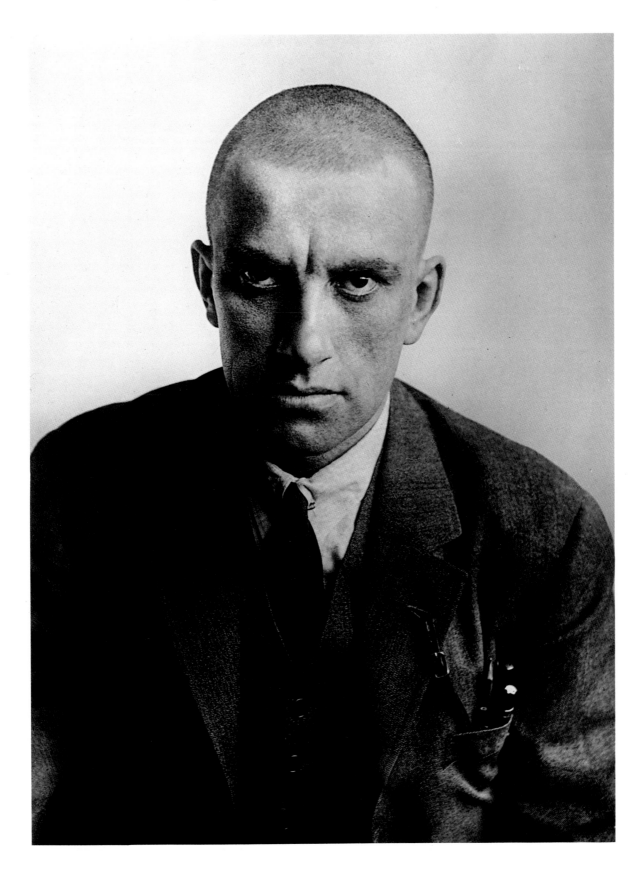

20 Portrait Vladimir Majakovskij, 1924
Portrait of Vladimir Mayakovsky, 1924
Portrait de Vladimir Majakovskij, 1924

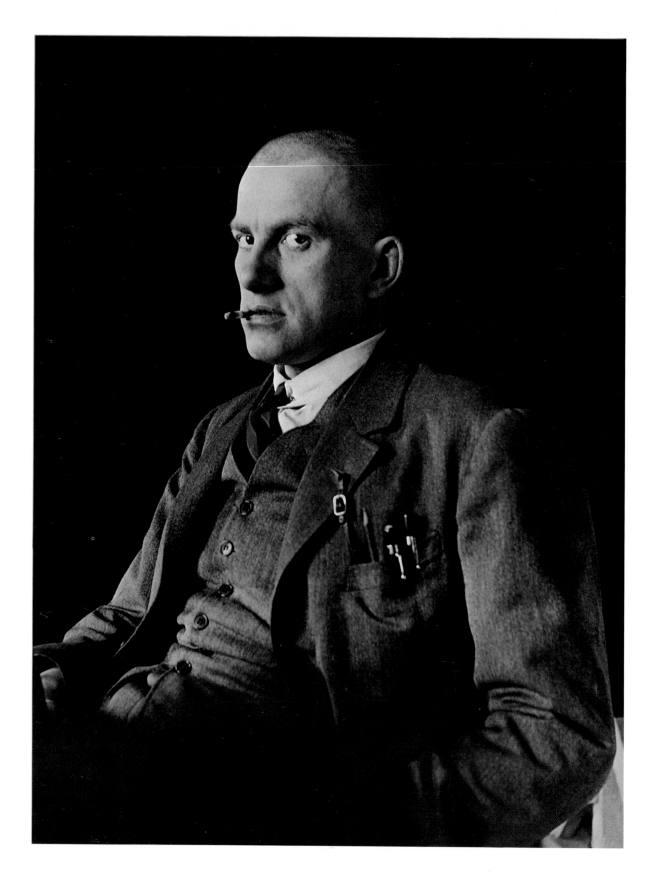

21 Portrait Vladimir Majakovskij, 1924
Portrait of Vladimir Mayakovsky, 1924
Portrait de Vladimir Majakovskij, 1924

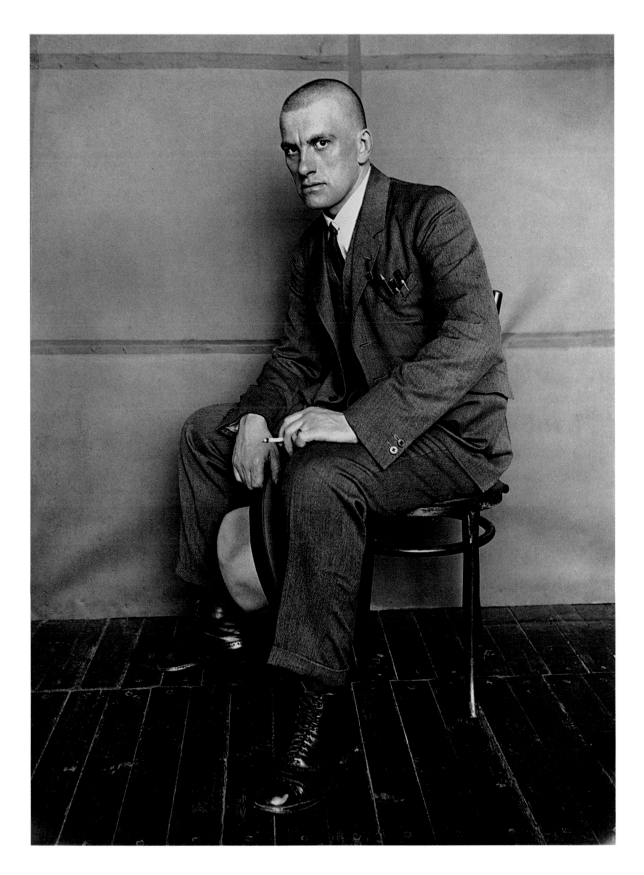

22 Portrait Vladimir Majakovskij, 1924
Portrait of Vladimir Mayakovsky, 1924
Portrait de Vladimir Majakovskij, 1924

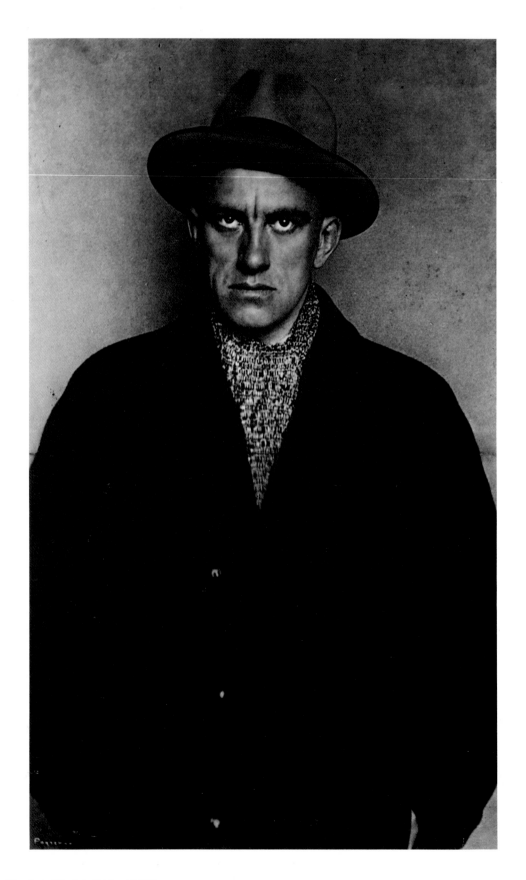

23 Portrait Vladimir, Majakovskij, 1924
Portrait of Vladimir Mayakovsky, 1924
Portrait de Vladimir Majakovskij, 1924

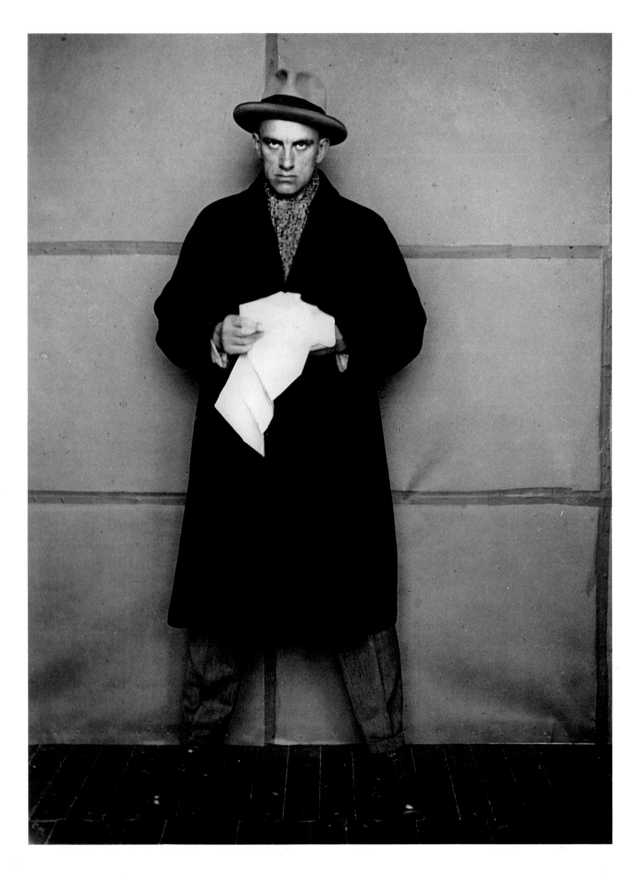

24 Portrait Vladimir Majakovskij, 1924
 Portrait of Vladimir Mayakovsky, 1924
 Portrait de Vladimir Majakovskij, 1924

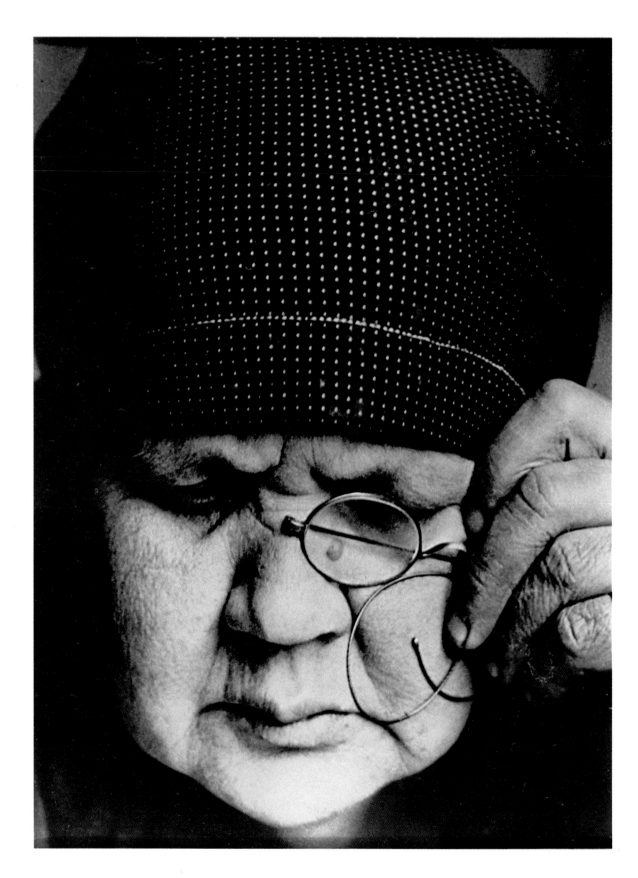

25 Portrait der Mutter, 1924
Portrait of Mother, 1924
Portrait de sa mère, 1924

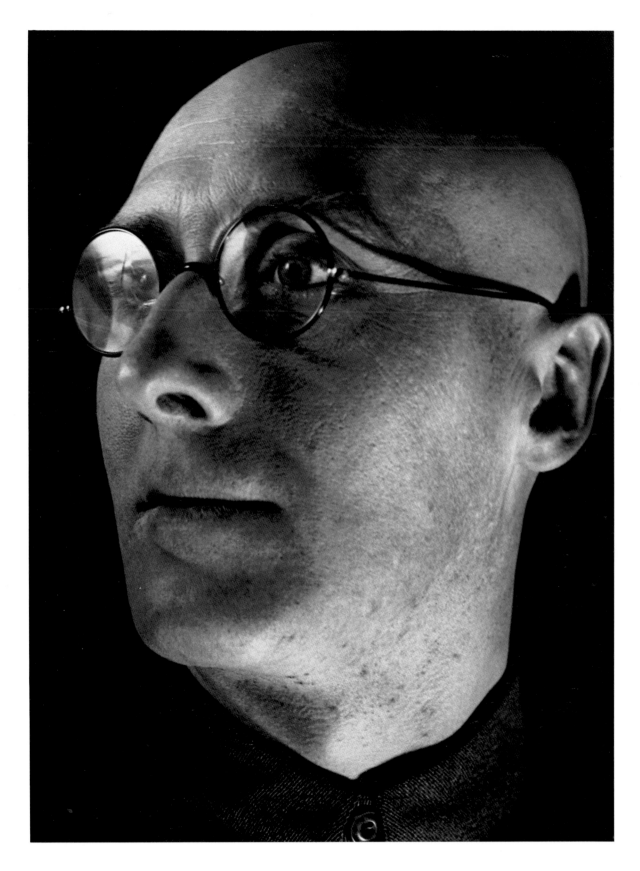

26 Portrait des Schriftstellers Sergej Tret'jakov, 1928
Portrait of the writer Sergej Tretiakov, 1928
Portrait de l'écrivain Sergej Tret'jakov, 1928

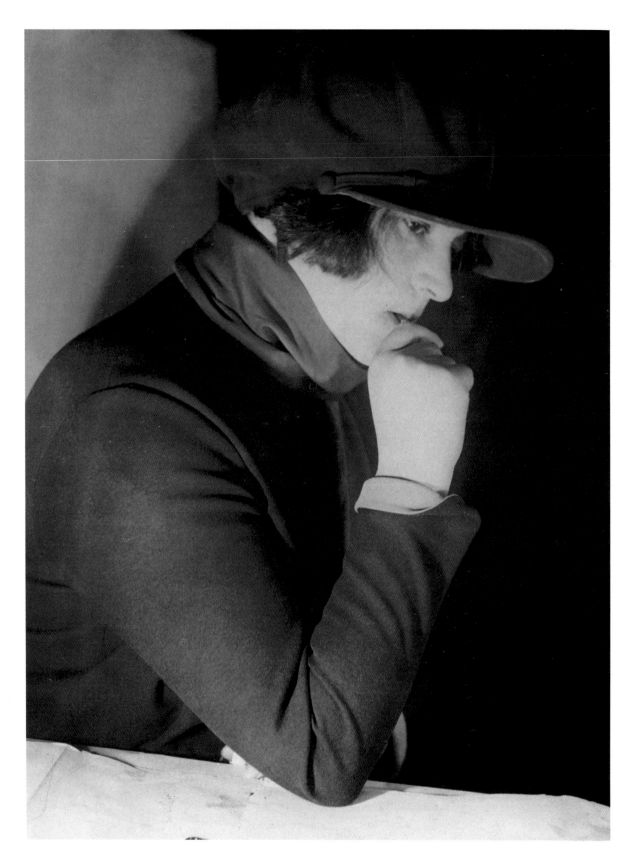

27 Portrait der Filmerin Esfir Šub, 1924
 Portrait of filmmaker Esfir Shub, 1924
 Portrait de la cinéaste Esfir Šub, 1924

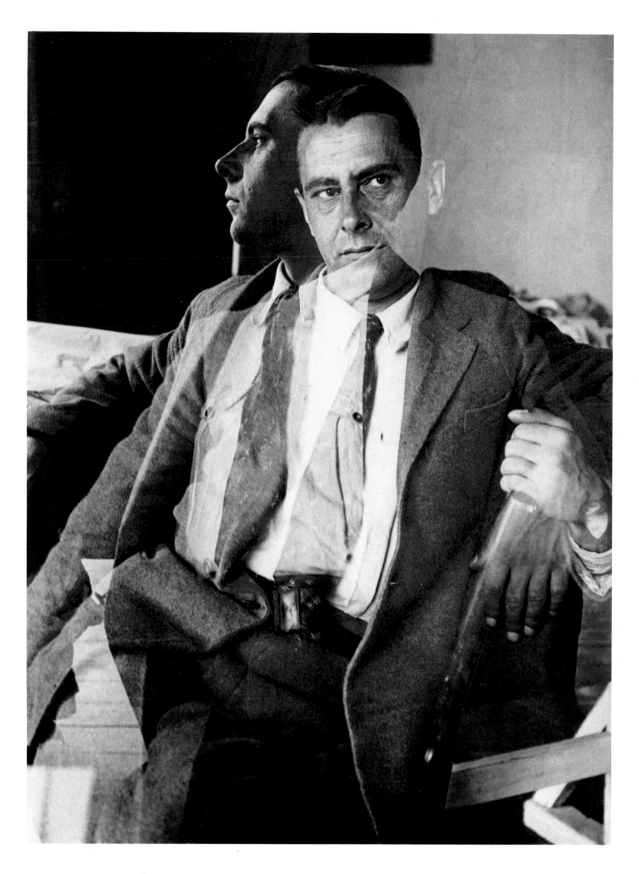

28 Portrait des Künstlers Alexandr Ševčenko, 1924
Portrait of the artist Alexander Shevchenko, 1924
Portrait de l'artiste Alexandr Ševčenko, 1924

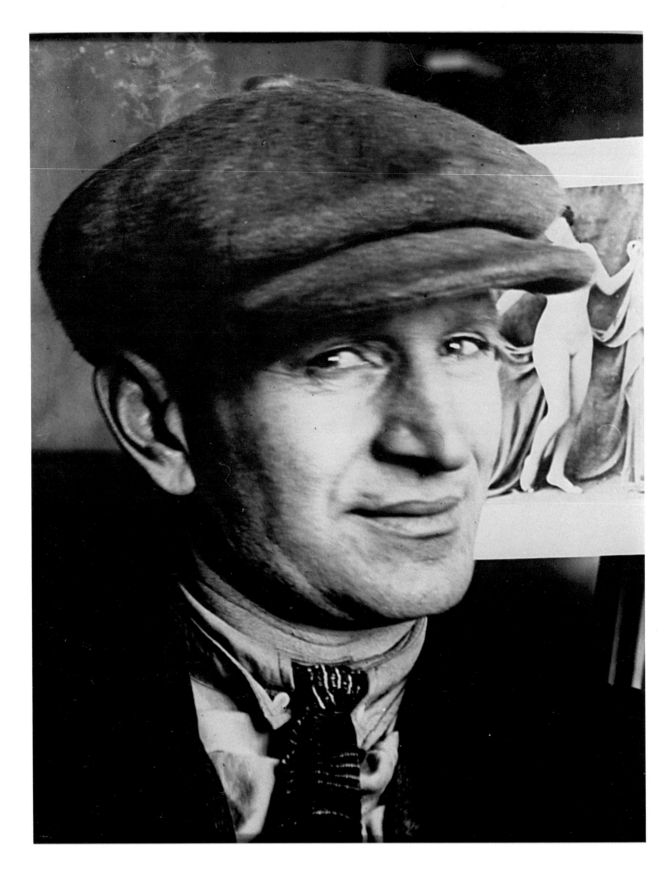

29 Portrait des Künstlers Anton Lavinskij, 1924
Portrait of the artist Anton Lavinskii, 1924
Portrait de l'artiste Anton Lavinskij, 1924

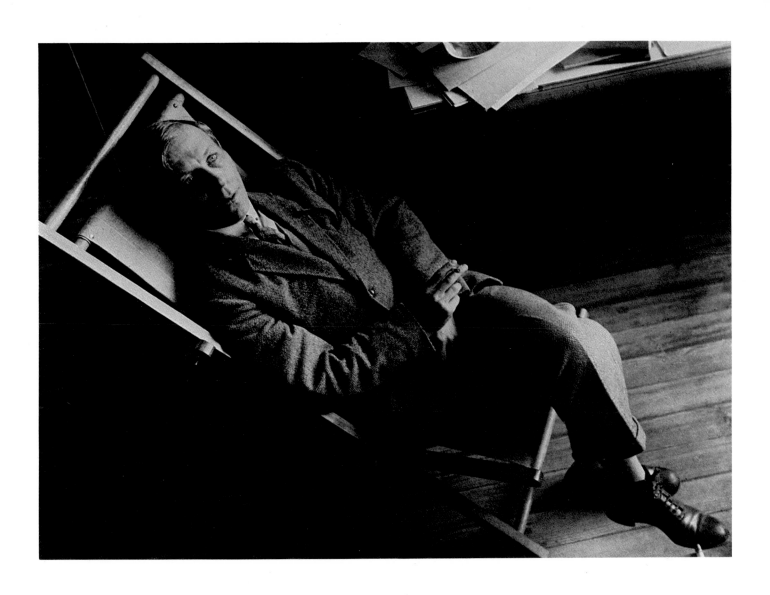

30 Portrait des Schriftstellers Nikolaj Aseev, 1927
Portrait of the writer Nicolai Aseev, 1927
Portrait de l'écrivain Nikolaj Aseev, 1927

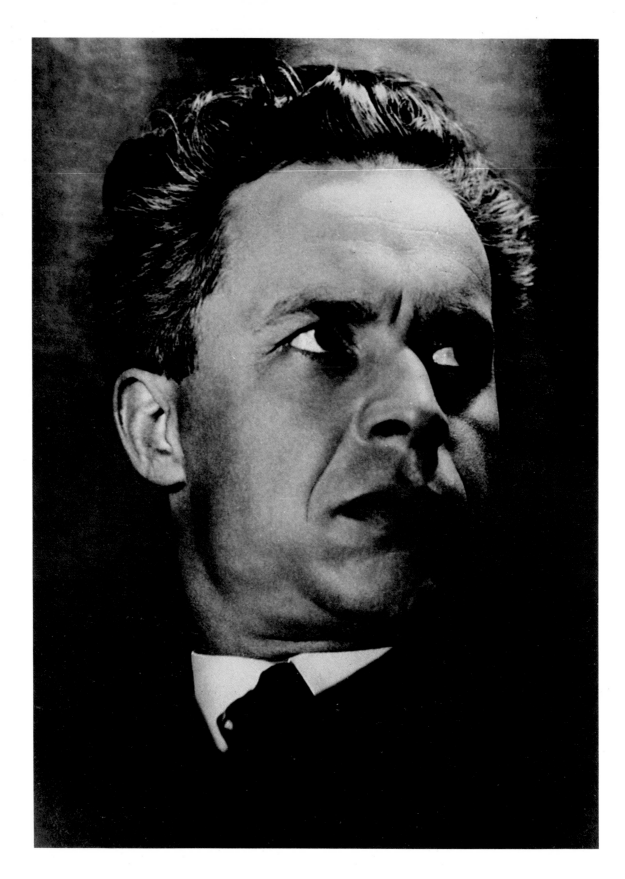

31 Portrait des Filmers Alexander Dovčenko, 1930
Portrait of the filmmaker Alexander Dovchenko, 1930
Portrait du cinéaste Alexander Dovčenko, 1930

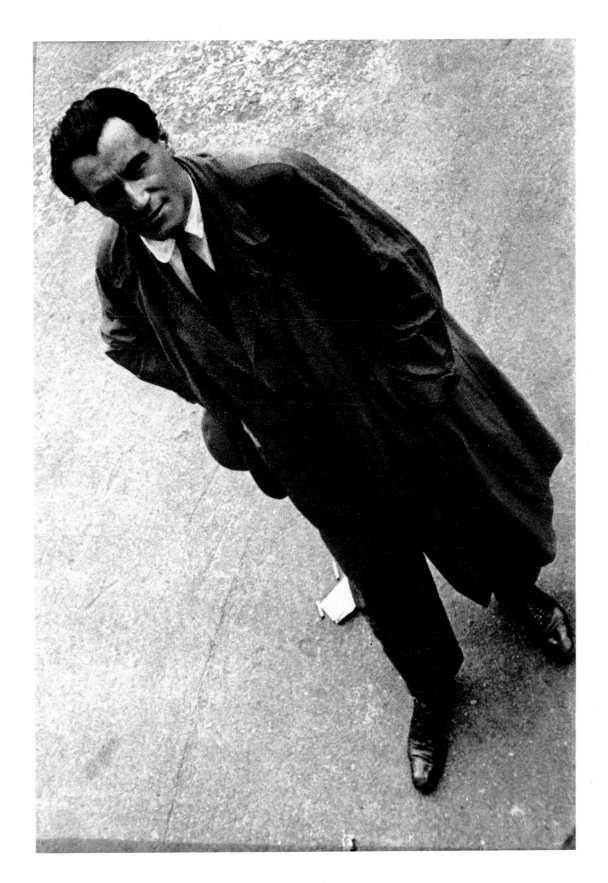

32 Portrait des Schriftstellers Valentin Kataev, 1929
 Portrait of the writer Valentin Kataev, 1929
 Portrait de l'écrivain Valentin Kataev, 1929

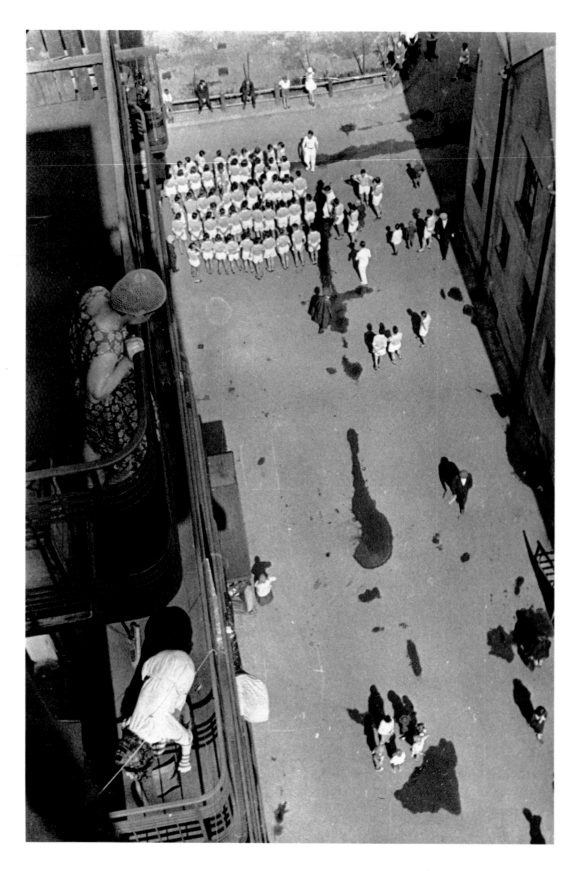

33 Sammlung zur Demonstration auf dem Hinterhof der VChUTEMAS (Höhere künstlerisch-technische Werkstätten), 1928
Gathering for the demonstration in the courtyard of the VChUTEMAS (Higher Institute of Technics and Art), 1928
Rassemblement pour une manifestation dans l'arrière-cour des VChUTEMAS (Ateliers supérieurs d'arts et techniques), 1928

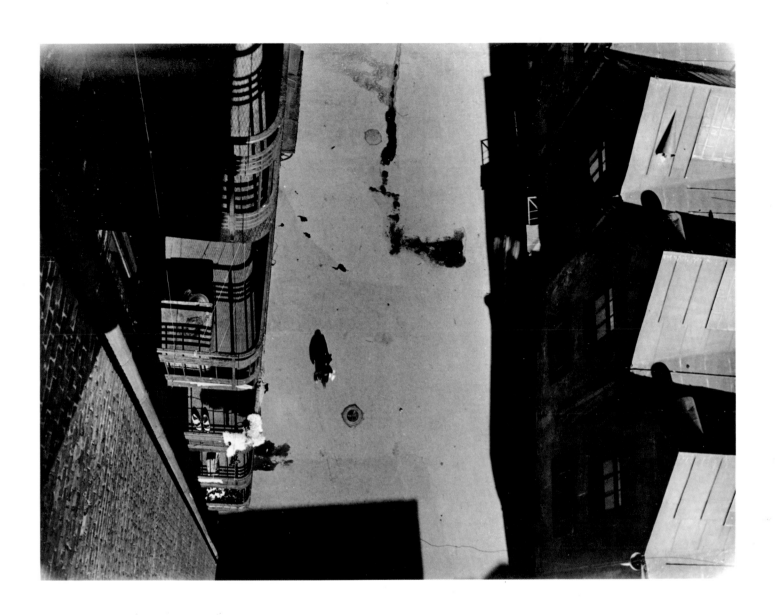

34 Hinterhof der VChUTEMAS mit Balkonen, 1928
Courtyard of the VChUTEMAS with balconies, 1928
Arrière-cour des VChUTEMAS avec balcons, 1928

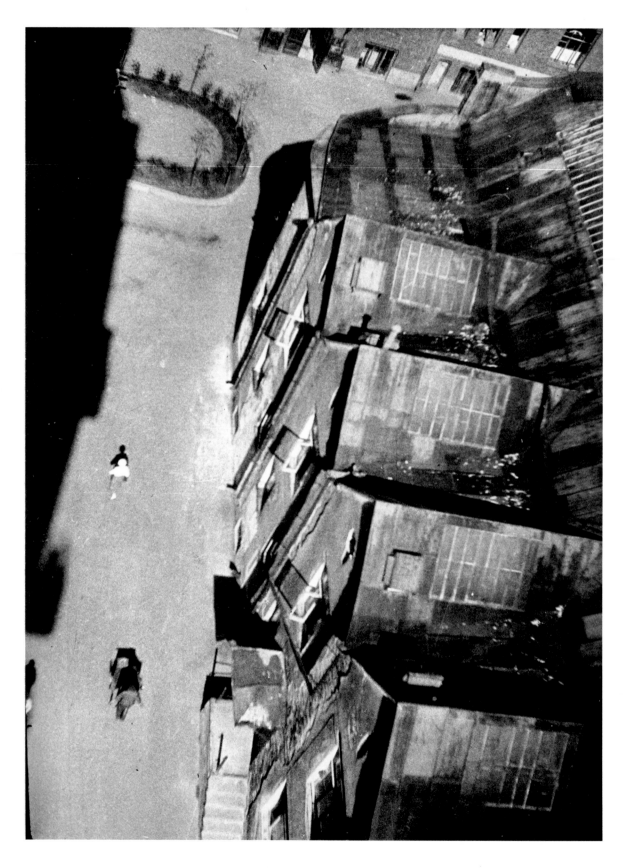

35 Hinterhof der VChUTEMAS, 1926
Courtyard of the VChUTEMAS, 1926
Arrière-cour des VChUTEMAS, 1926

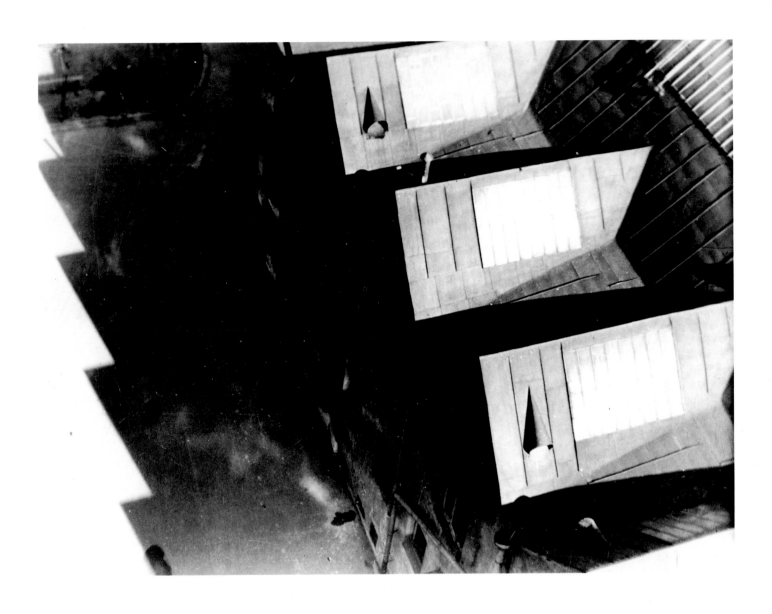

36 Hinterhof der VChUTEMAS, 1928
 Courtyard of the VChUTEMAS, 1928
 Arrière-cour des VChUTEMAS, 1928

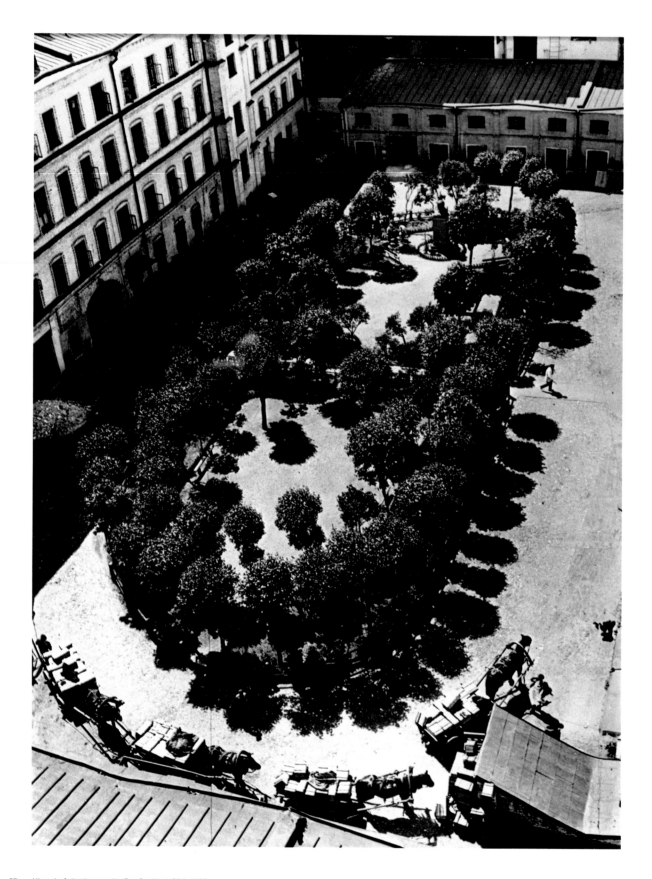

37 Hinterhofgärtchen an der Straße des 1. Mai, 1926
 Small courtyard garden on First of May Street, 1926
 Jardinet d'arrière-cour Rue du 1er Mai, 1926

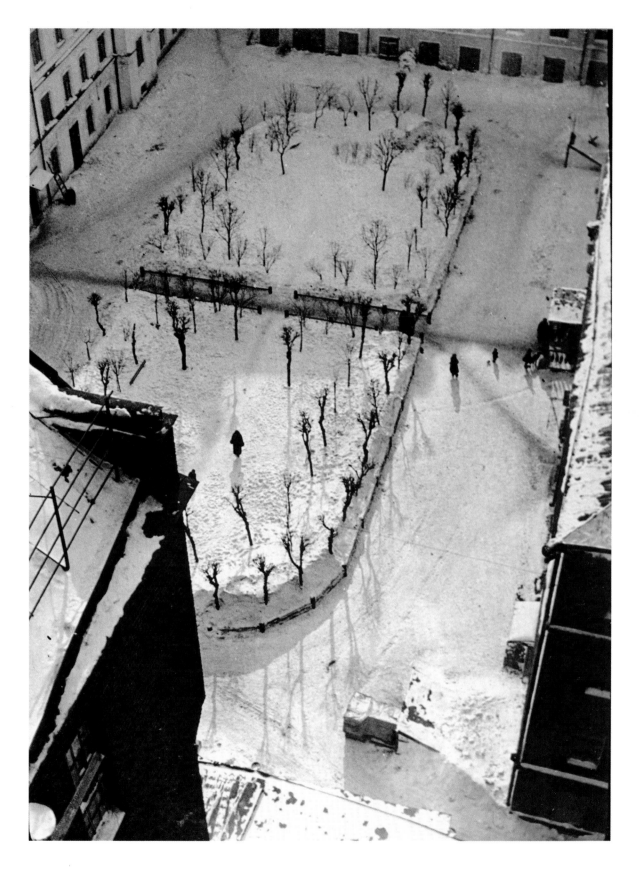

38 Hinterhofgärtchen an der Straße des 1. Mai, 1926
 Small courtyard garden on First of May Street, 1926
 Jardinet d'arrière-cour Rue du 1er Mai, 1926

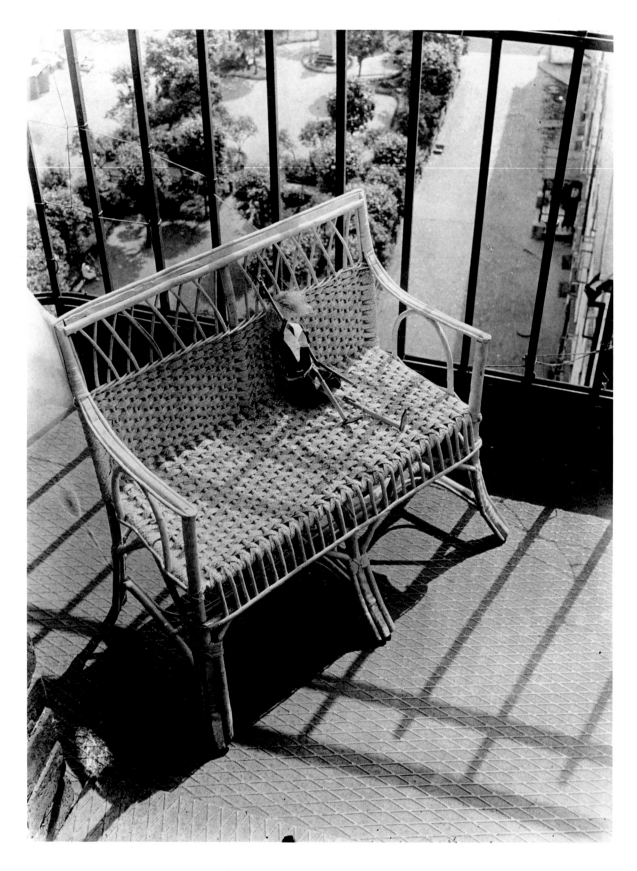

39 Puppenkarikatur der Schauspielerin A. Chochlova, 1926 (Hinterhofgärtchen an der Straße des 1. Mai)
 Puppetcaricature of the actress A. Chochlova, 1926 (Small courtyard garden on the First of May Street)
 Caricature de marionette de l'actrice A. Chochlova, 1926 (jardinet d'arrière-cour Rue du 1er Mai)

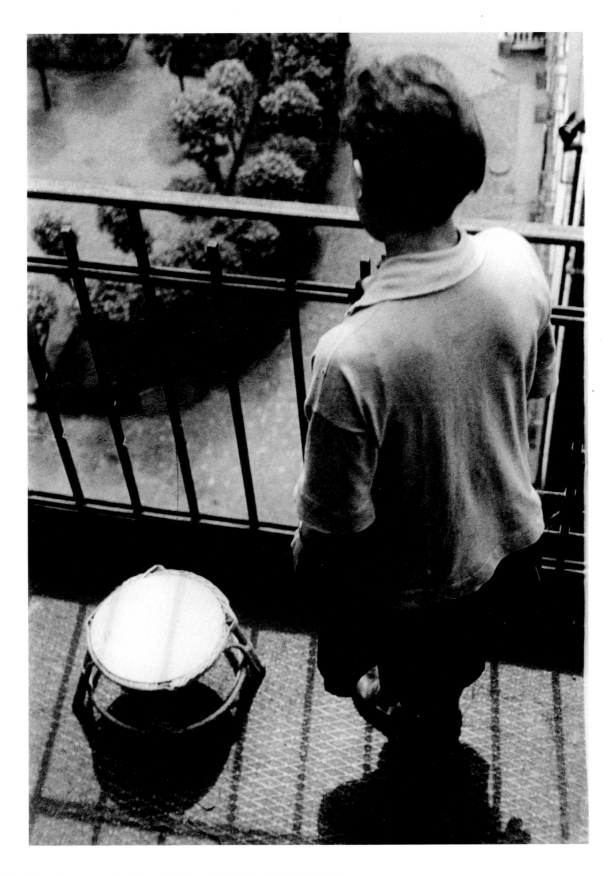

40 Varvara Stepanova auf dem Balkon, 1928 (Hinterhofgärtchen an der Straße des 1. Mai)
Varvara Stepanova on the balcony, 1928 (Small courtyard garden on the First of May Street)
Varvara Stepanova au balcon, 1928 (jardinet d'arrière-cour Rue du 1er Mai)

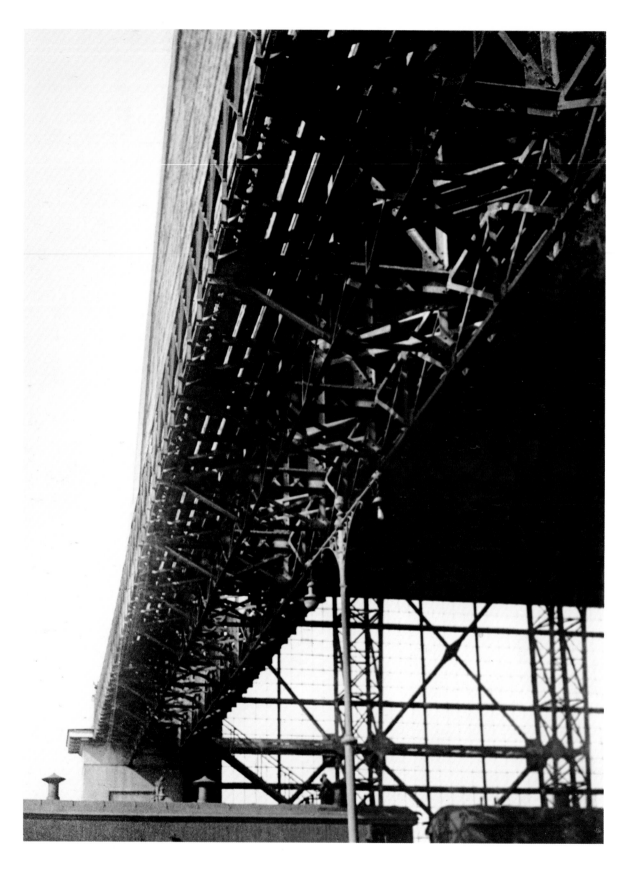

41 Brjansker Bahnhof, 1927
 Briansk train station, 1927
 Gare de Brjansk, 1927

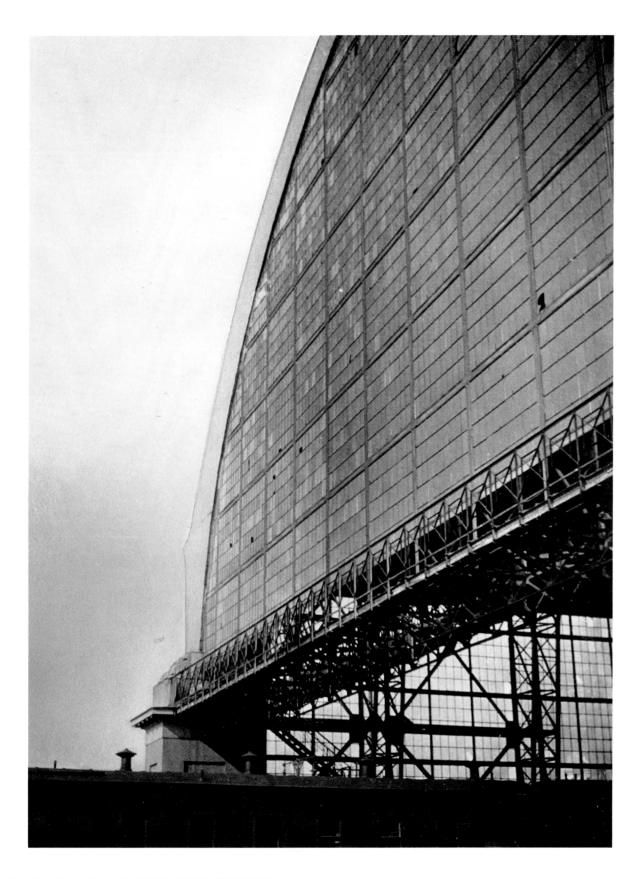

42 Brjansker Bahnhof. Arbeit an dem Film ,,Moskau im Oktober'', 1927
Briansk train station. Working on the film ,,Moscow in October'', 1927
Gare de Brjansk. Tournage du film ,,Moscou en Octobre'', 1927

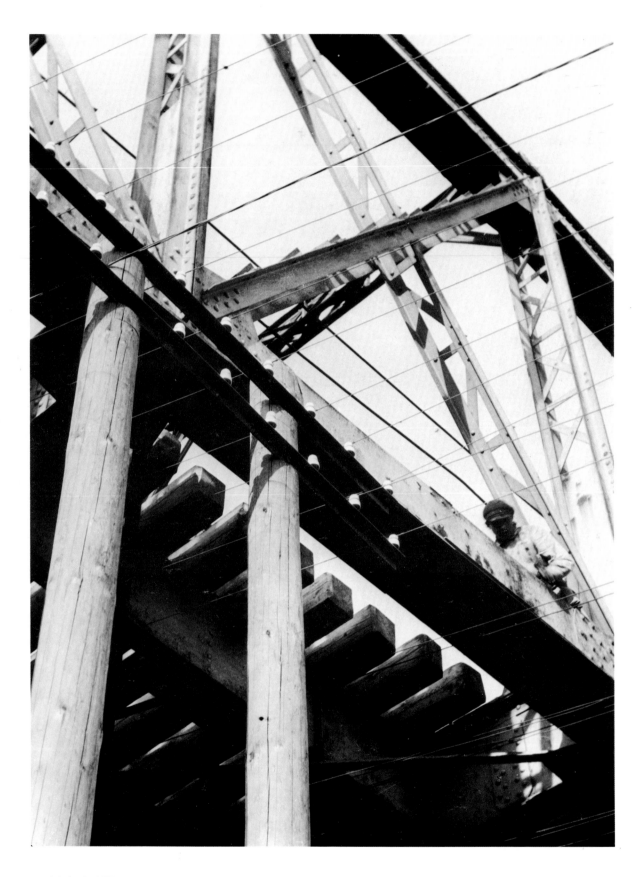

43 Eisenbahnbrücke, 1927
Railroad bridge, 1927
Pont de chemin-de-fer, 1927

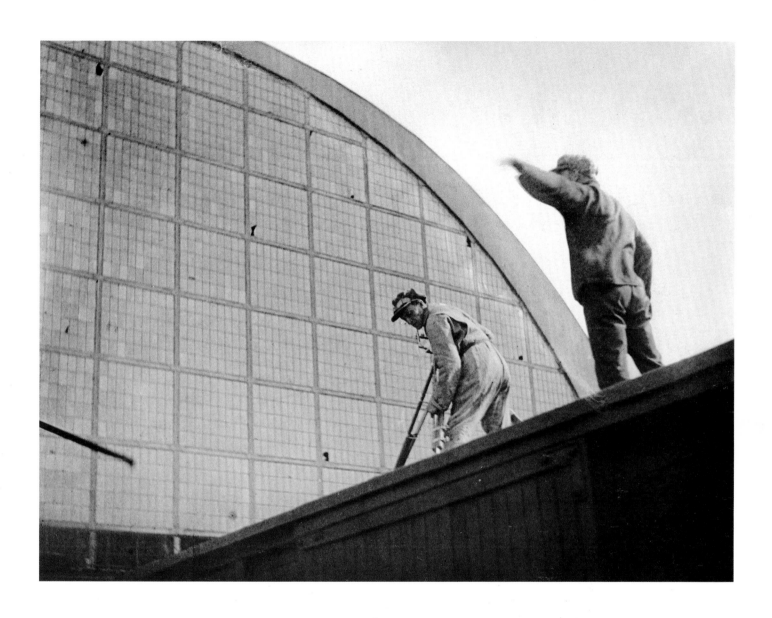

44 Brjansker Bahnhof, 1927
Briansk train station, 1927
Gare de Brjansk, 1927

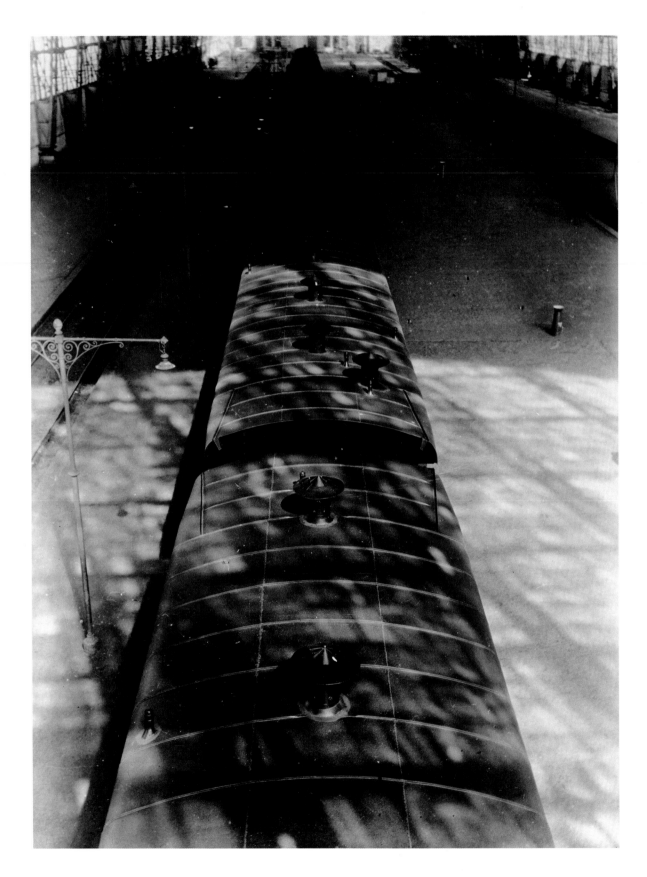

45 Brjansker Bahnhof, 1927
Briansk train station, 1927
Gare de Brjansk, 1927

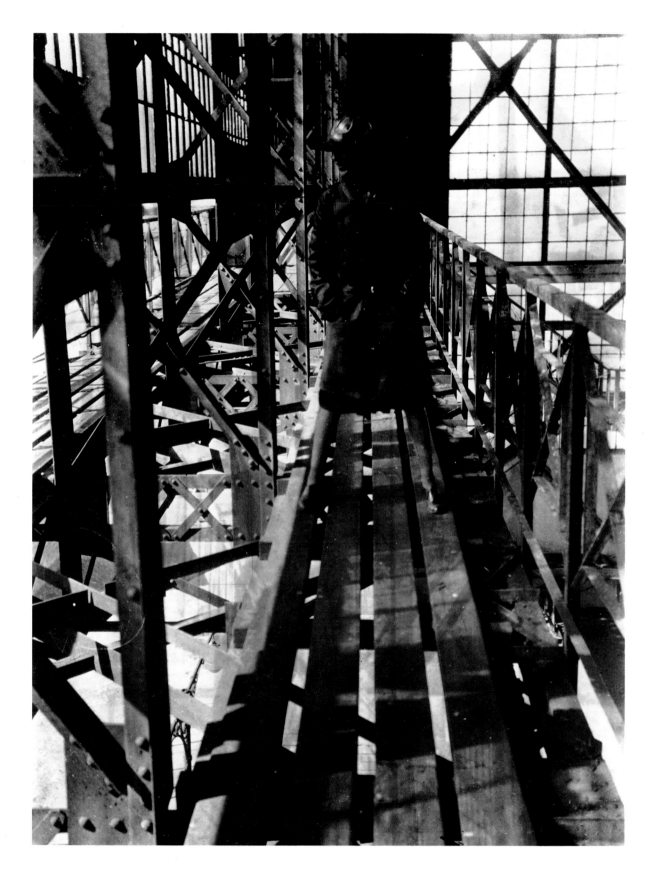

46 A. Chochlova zwischen den Konstruktionen des Brjansker Bahnhofs, 1927
 A. Chochlova amongst the structures of the Briansk train station, 1927
 A. Chochlova parmi les constructions de la gare de Brjansk, 1927

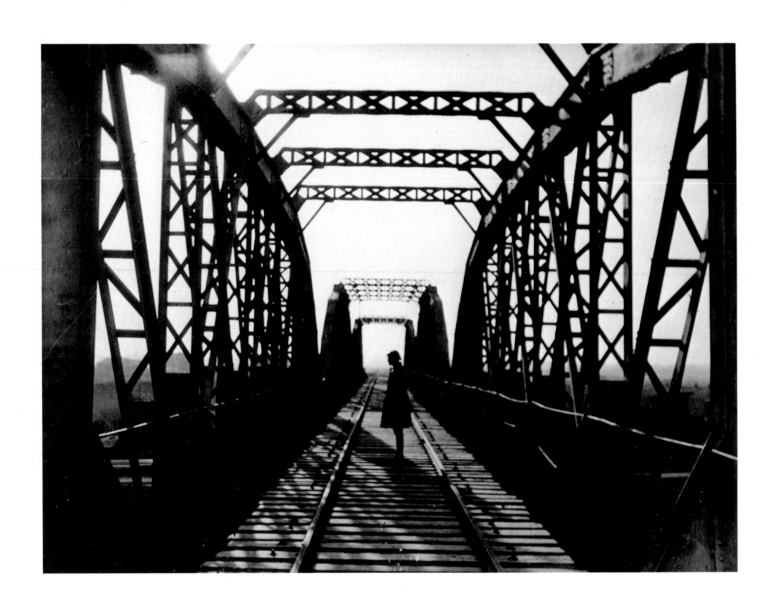

47 Ein Stück Moskau, 1926
 A part of Moscow, 1926
 Coin de Moscou, 1926

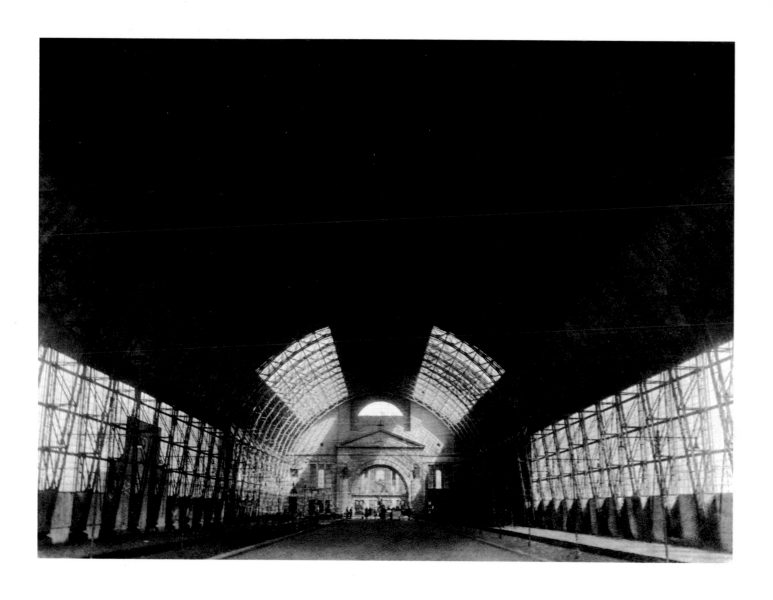

48 Brjansker Bahnhof, 1927
Briansk train station, 1927
Gare de Brjansk, 1927

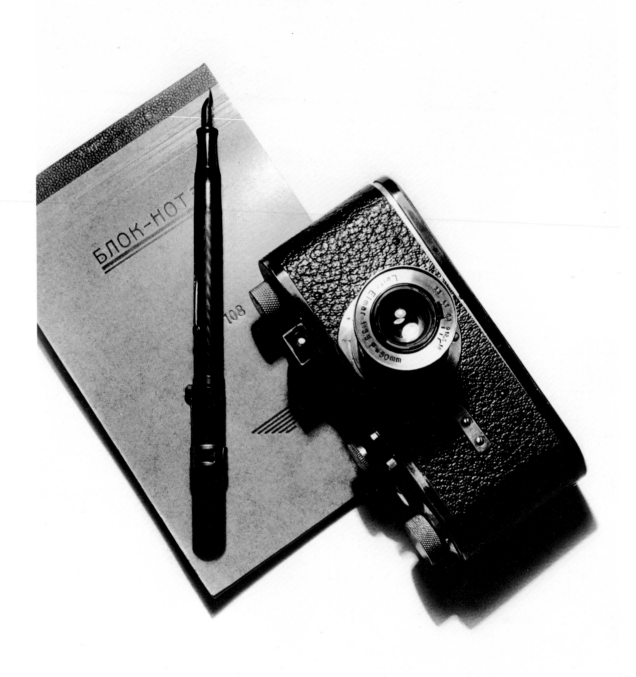

49 Stilleben mit Leica, 1929
 Still-life with Leica, 1929
 Nature-morte avec Leica, 1929

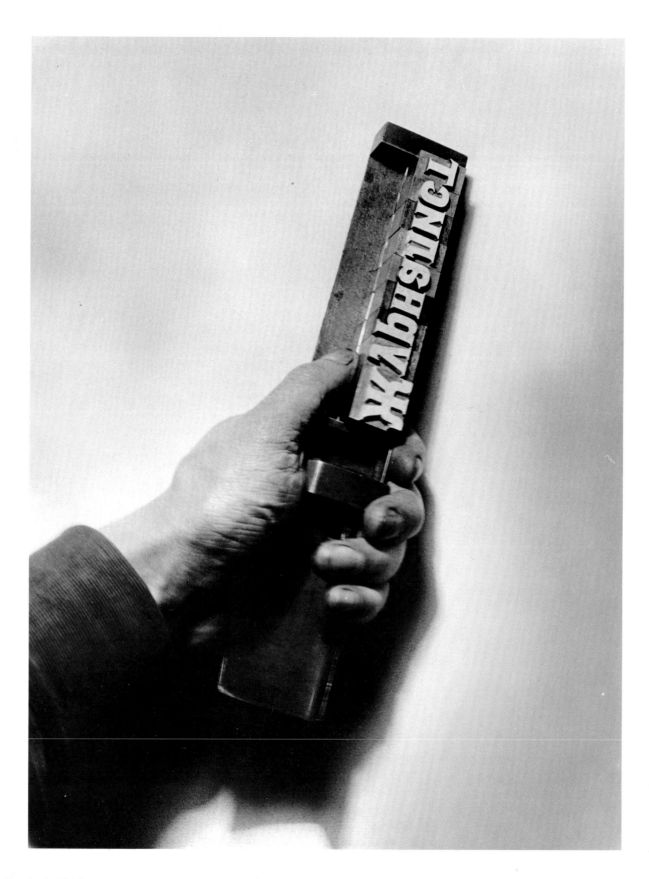

50 Hand mit Schriftsatz „Journalist", 1930
Hand with type-set word „Journalist", 1930
Main avec „journaliste" en composition typo, 1930

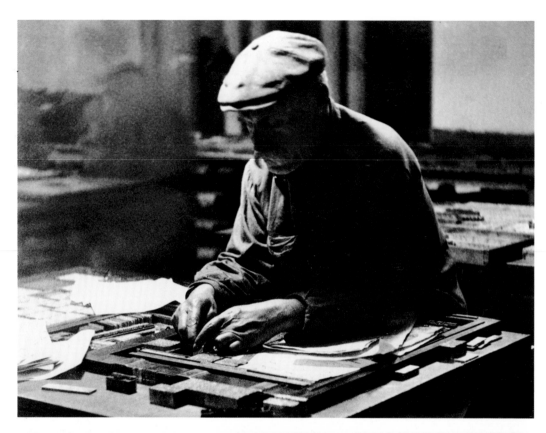

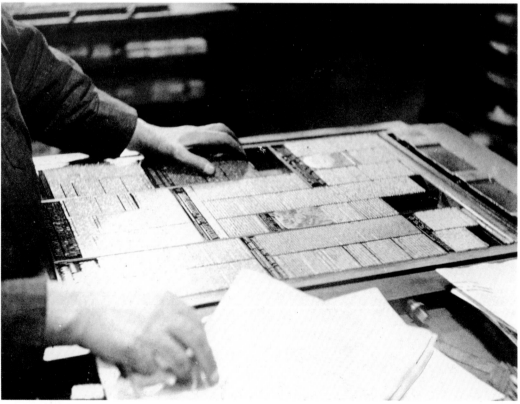

51–52 Der Metteur paßt die Spalten und Zeilen einander an, 1928
Typesetter fitting columns and lines, 1928
Le metteur ajuste les lignes aux colomnes, 1928

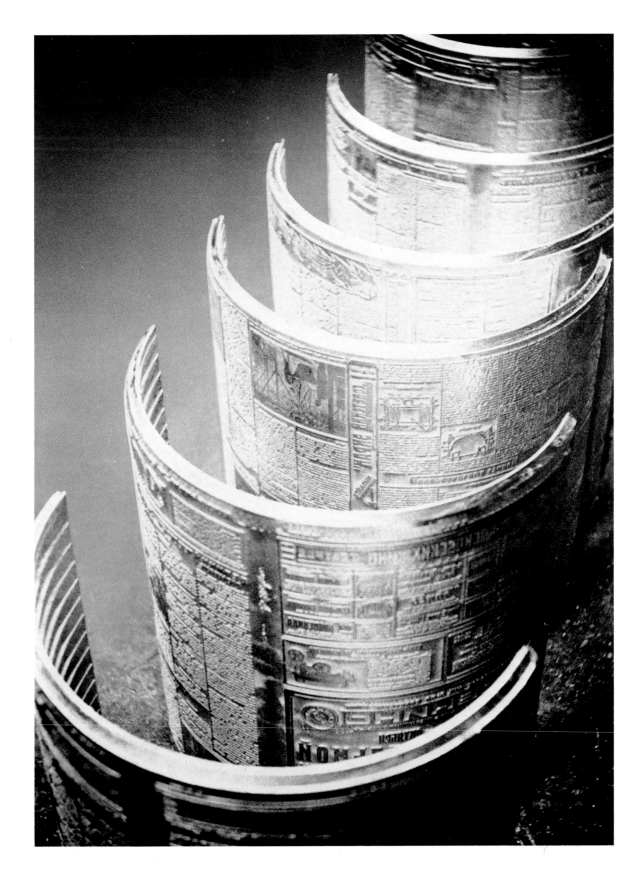

53 Stereotypien, 1928
 Stereotype plates, 1928
 Stéréotypies, 1928

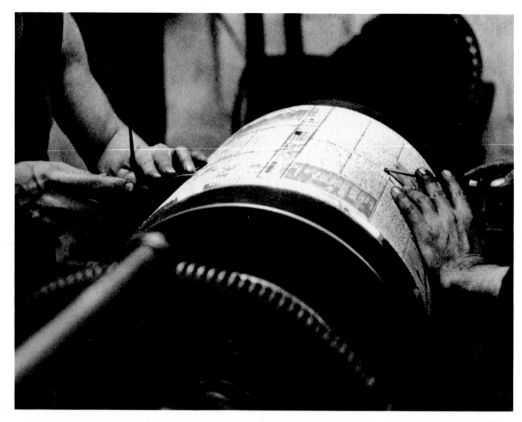

54

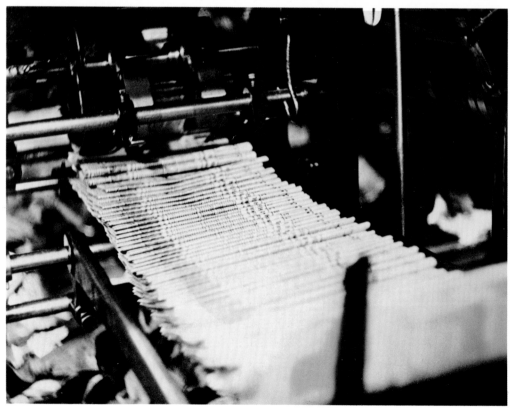

55

54 Der Stereotypie wird auf der Walze der letzte Schliff gegeben, 1928
The stereotype plate given the final touch on the roller, 1928
Dernières rectifications du stéréo sur cylindre, 1928

Rotationsmaschine, 1928 55
Rotation Machine, 1928
Rotatives, 1928

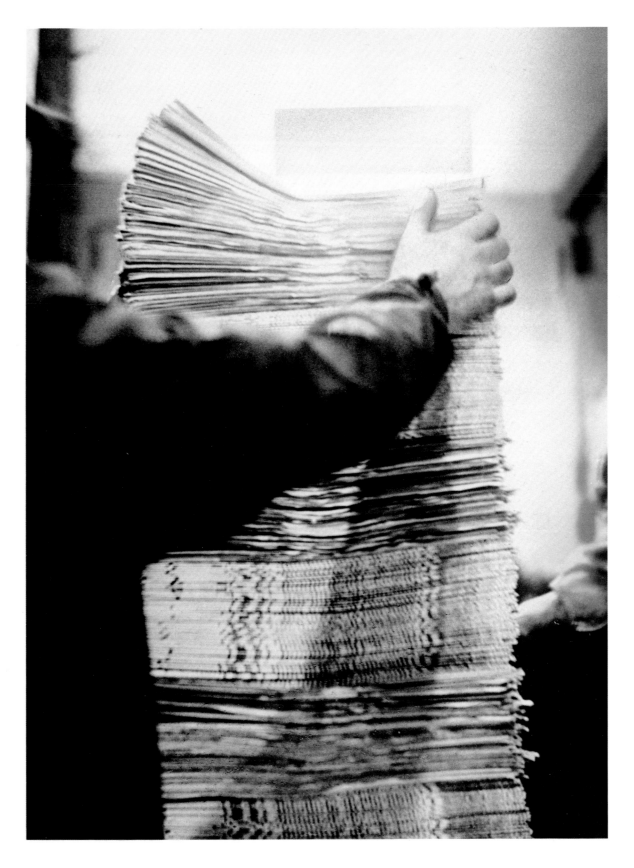

56 Frisch gedruckte Zeilen, 1928
Freshly printed lines, 1928
Lignes fraîches-imprimées, 1928

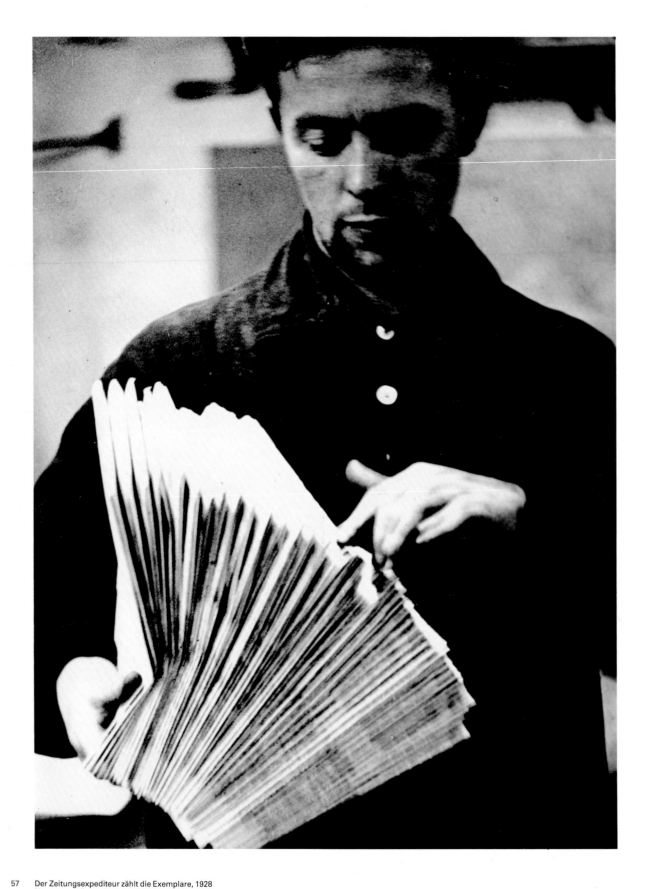

57 Der Zeitungsexpediteur zählt die Exemplare, 1928
 Newspaper dispatcher counting the copies, 1928
 L'expéditeur de journaux compte les exemplaires, 1928

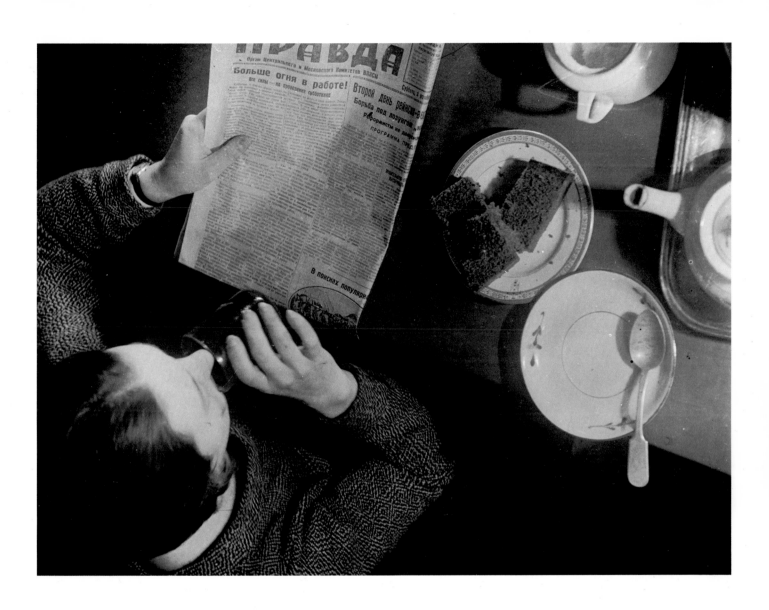

58 Morgenausgabe, 1928
 Morning edition, 1928
 Edition du matin, 1928

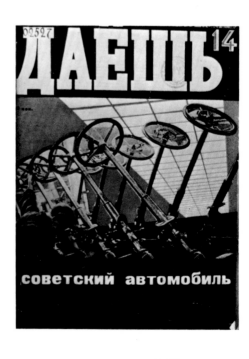
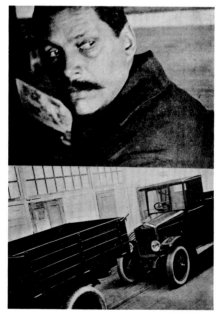
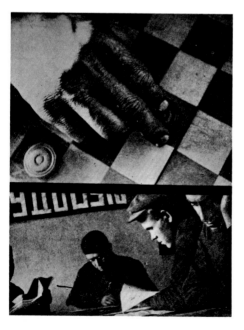

59—61 Umschlag und Seiten aus der Zeitschrift DAEŠ, in der die AMO-Reportage abgedruckt ist, Moskau 1929
 Cover and pages of DAEŠ in which the automobile factory AMO is given coverage, Moscow 1929
 Couverture et pages du magazine DAEŠ dans lequel est publié le reportage sur AMO, Moscou 1929

62 Fotoreportage über die Autofabrik AMO, 1929
Photo-coverage of the automobile factory AMO, 1929
Reportage photographique sur l'usine automobile AMO, 1929

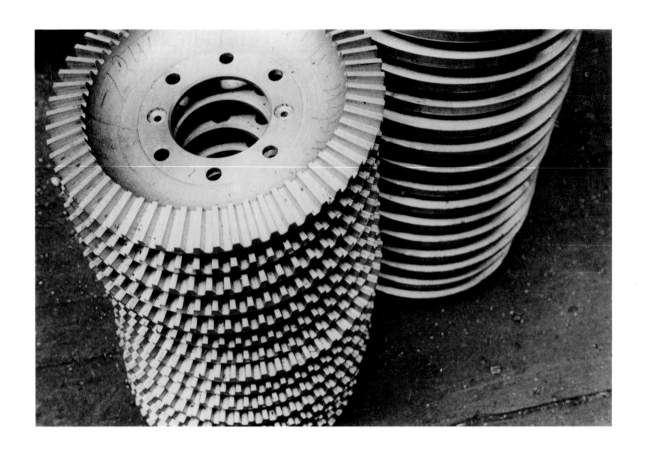

63 Zahnräder, 1929
 Cog-wheels, 1929
 Roues dentées, 1929

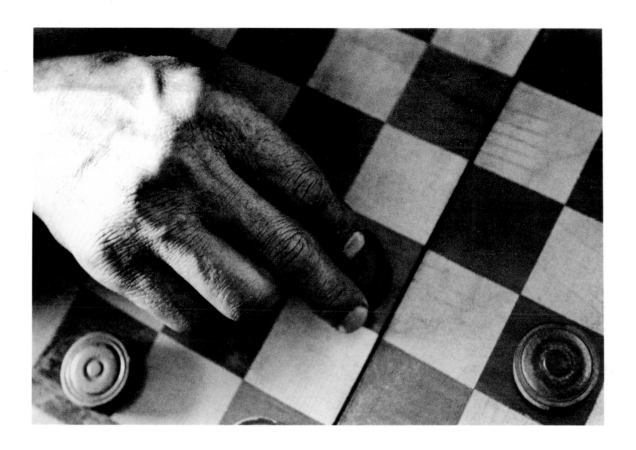

64 Mittagspause bei AMO, 1929
Lunch break at AMO, 1929
Pause de midi chez AMO, 1929

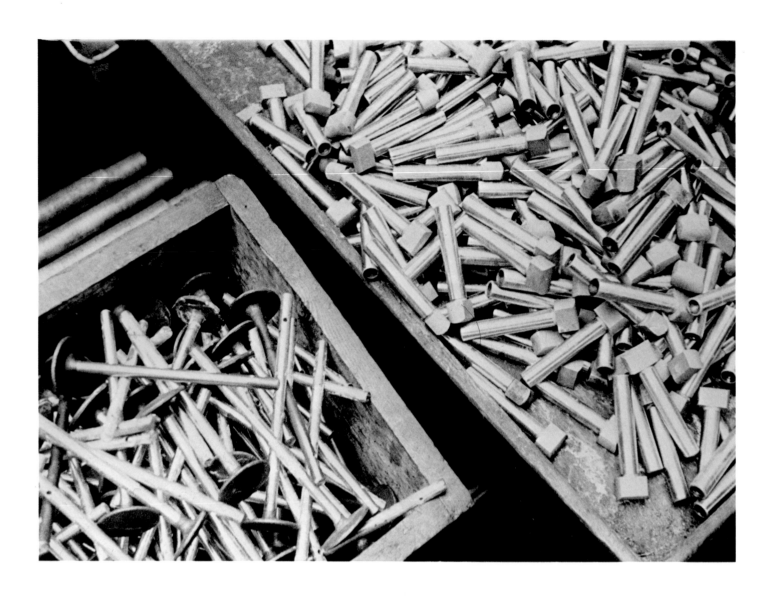

65 AMO, 1929
 AMO, 1929
 AMO, 1929

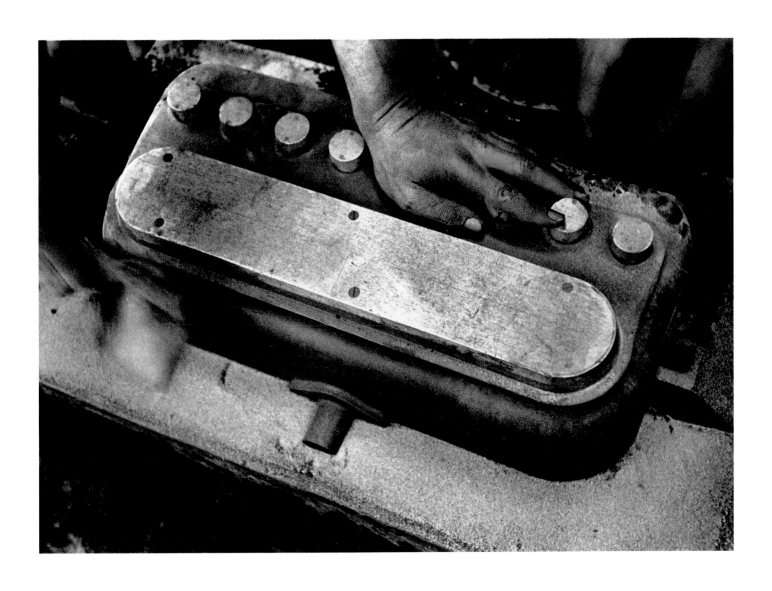

66 AMO, 1929
AMO, 1929
AMO, 1929

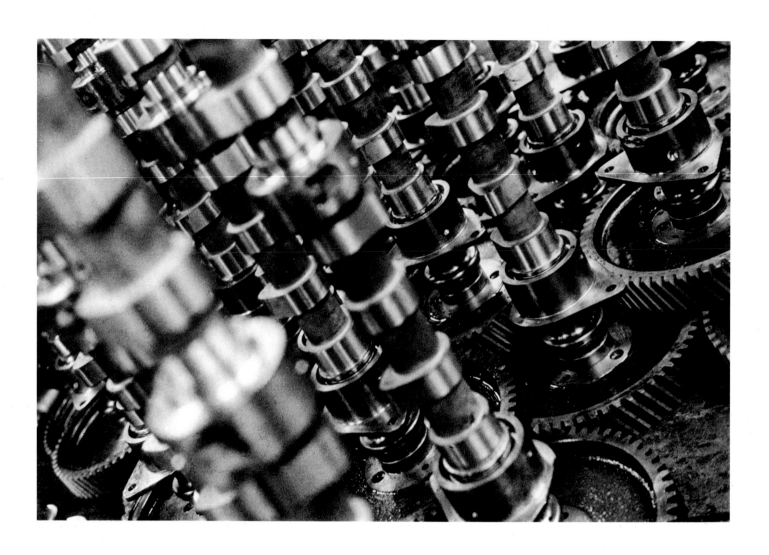

67 AMO, 1929
 AMO, 1929
 AMO, 1929

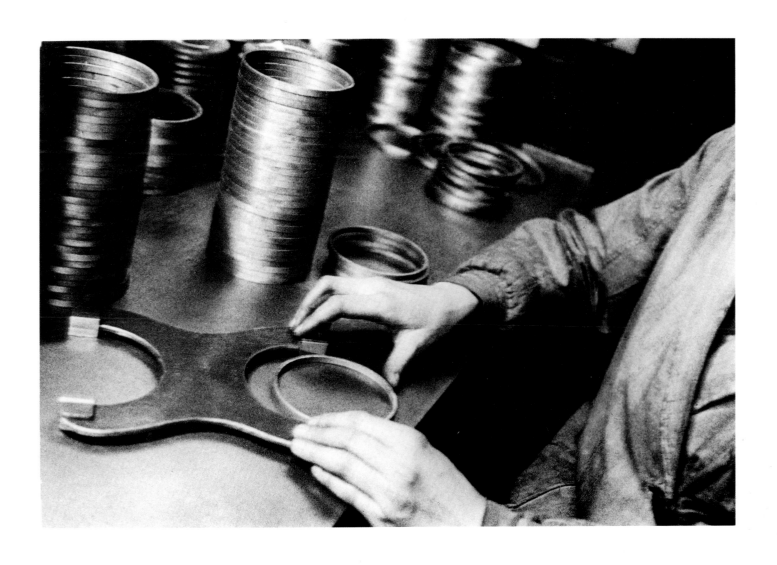

68 AMO, 1929
 AMO, 1929
 AMO, 1929

69 Mittagspause bei AMO, 1929
 Lunch break at AMO, 1929
 Pause de midi chez AMO, 1929

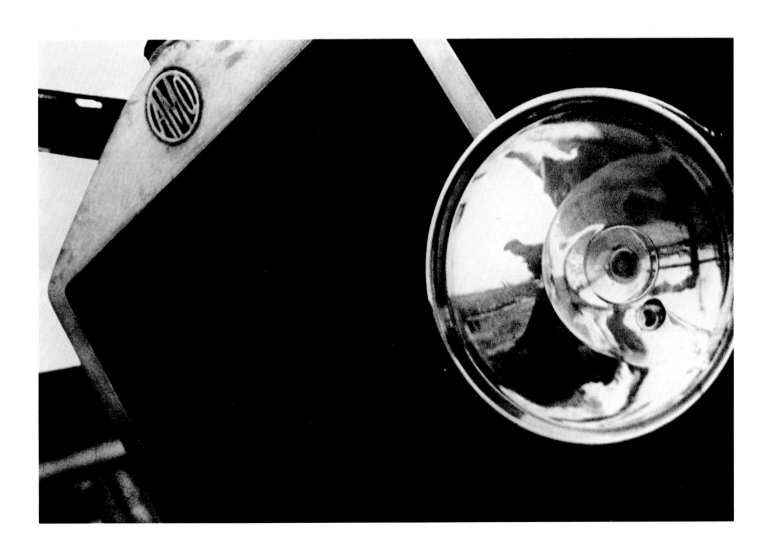

70 AMO, 1929
 AMO, 1929
 AMO, 1929

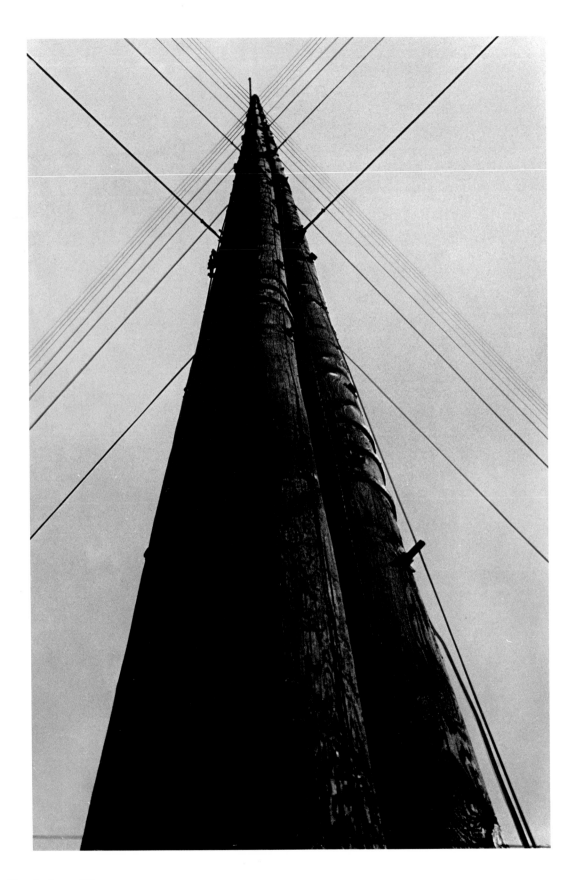

71 Sendemast, 1929
Transmission pole, 1929
Mât d'émission, 1929

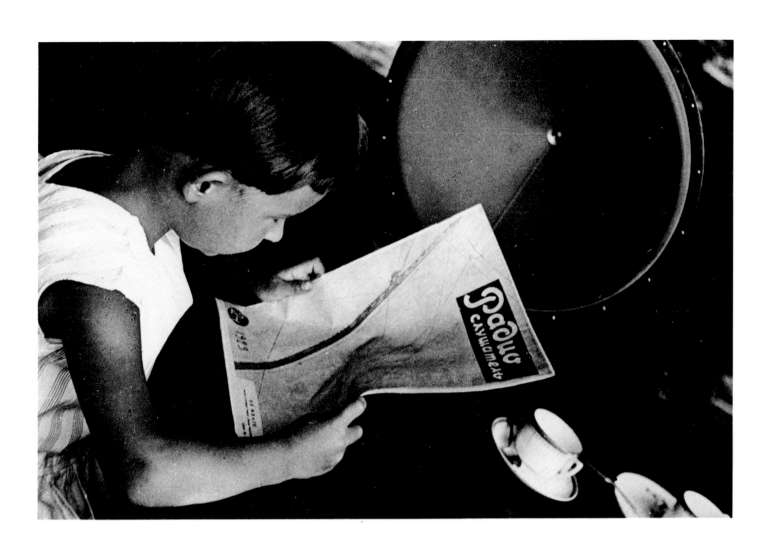

72 Rodčenkos Tochter beim Betrachten der Zeitschrift „Radiohörer", 1929
Rodchenko's daughter viewing the magazine „Radio listener", 1929
Fille de Rodčenko examinant la revue „L'Auditeur de Radio", 1929

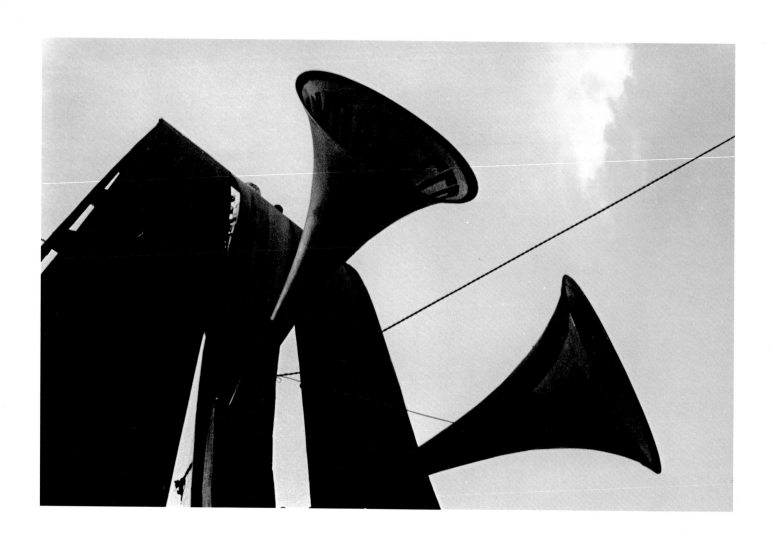

73 Lautsprecher, 1929
Loudspeaker, 1929
Haut-parleur, 1929

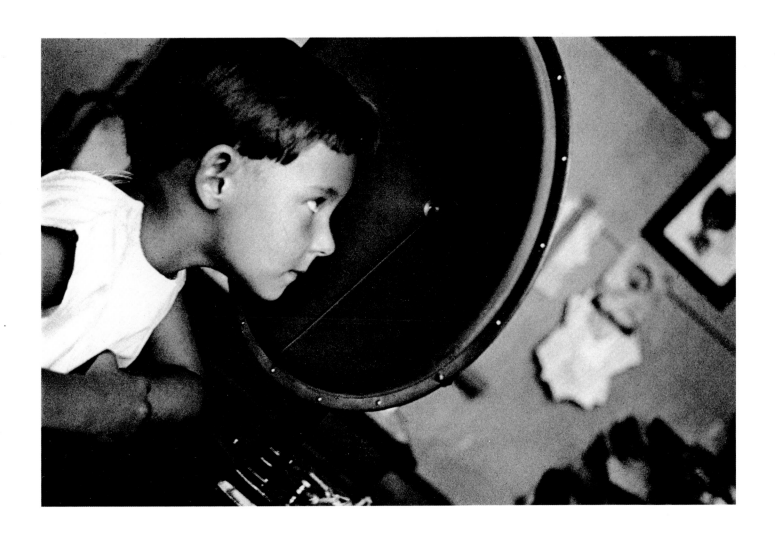

74 Radiohörer (Rodčenkos Tochter Varvara), 1929
Radio listener (Rodchenko's daughter Varvara), 1929
Auditeur de radio (Varvara, fille de Rodčenko), 1929

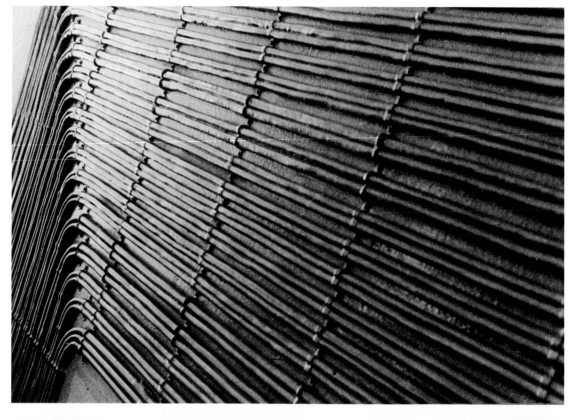

75

76

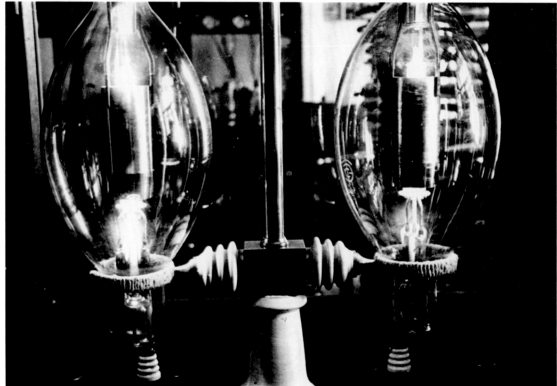

75 Im Rundfunkzentrum. Kabel, 1929
 Broadcasting center: cable, 1929
 Dans le centre de radiodiffusion. Cable, 1929

Radiolampen, 1929 76
Radio lamps, 1929
Lampes de radio, 1929

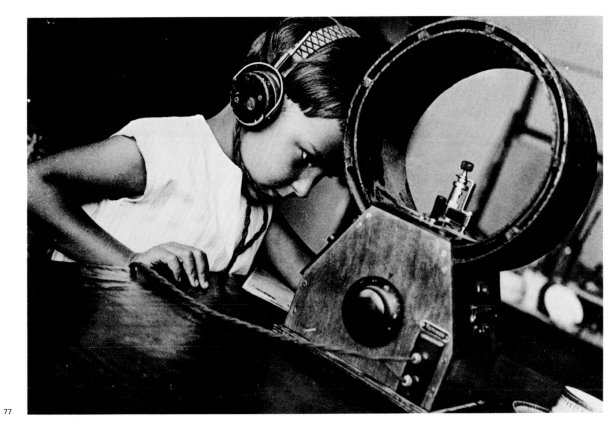

77

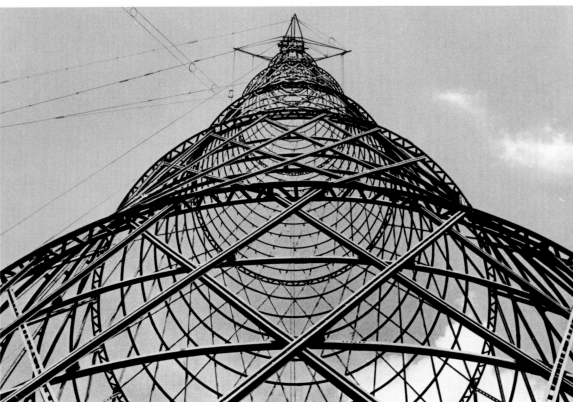

77 Radiohörer (Rodčenkos Tochter Varvara), 1929
Radio listener (Rodchenko's daughter Varvara), 1929
Auditeur de radio (Varvara, fille de Rodčenko), 1929

Šuchov-Sendeturm, 1929 78
Shuchov transmission tower, 1929
Tour de T.S.F. de Suchov, 1929

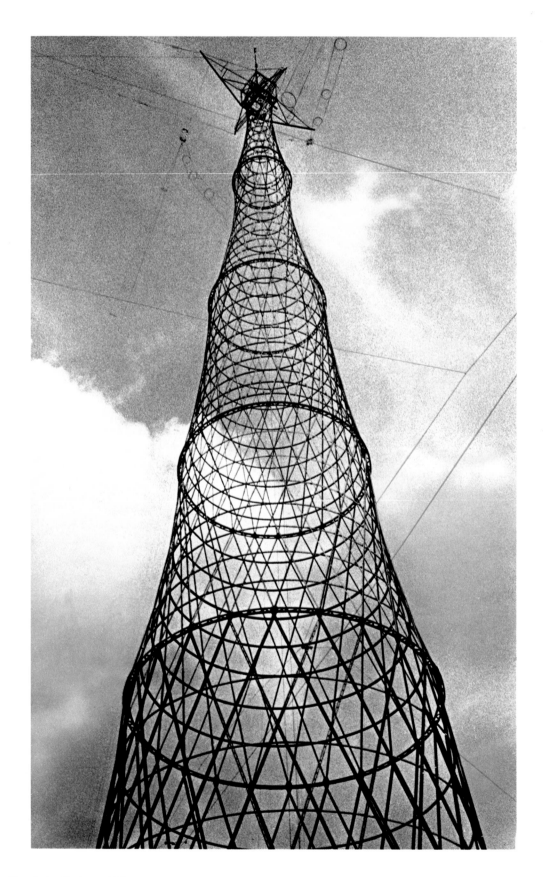

79 Šuchov-Sendeturm, 1929
 Shuchov transmission tower, 1929
 Tour de T.S.F. de Šuchov, 1929

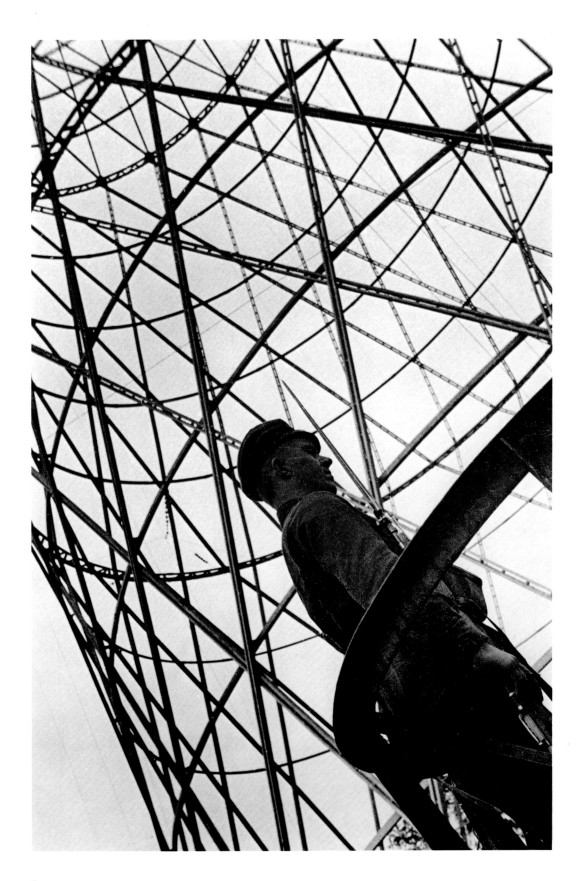

80 Šuchov-Sendeturm mit Wächter, 1929
Shuchov transmission tower with guards, 1929
Tour de T.S.F. de Šuchov avec gardiens, 1929

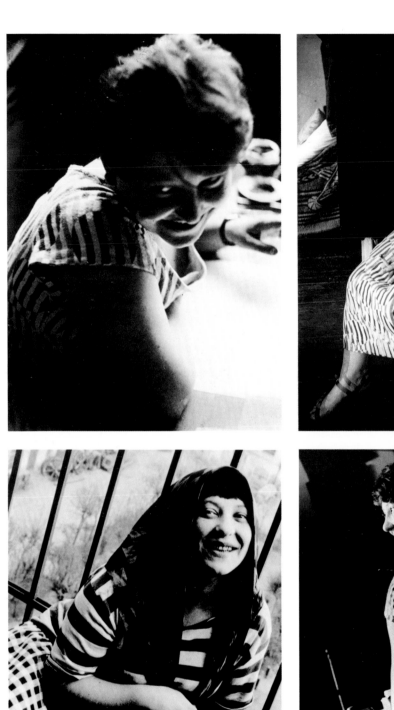
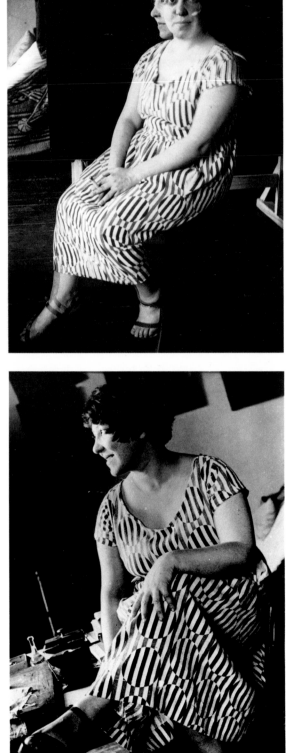

81–84 Drei Portraits (1925) und ein Doppelportrait (1924) Varvara Stepanova
 Three portraits (1925) and a double portrait (1924) of Varvara Stepanova
 Trois portraits (1925) et un double portrait (1924) de Varvara Stepanova

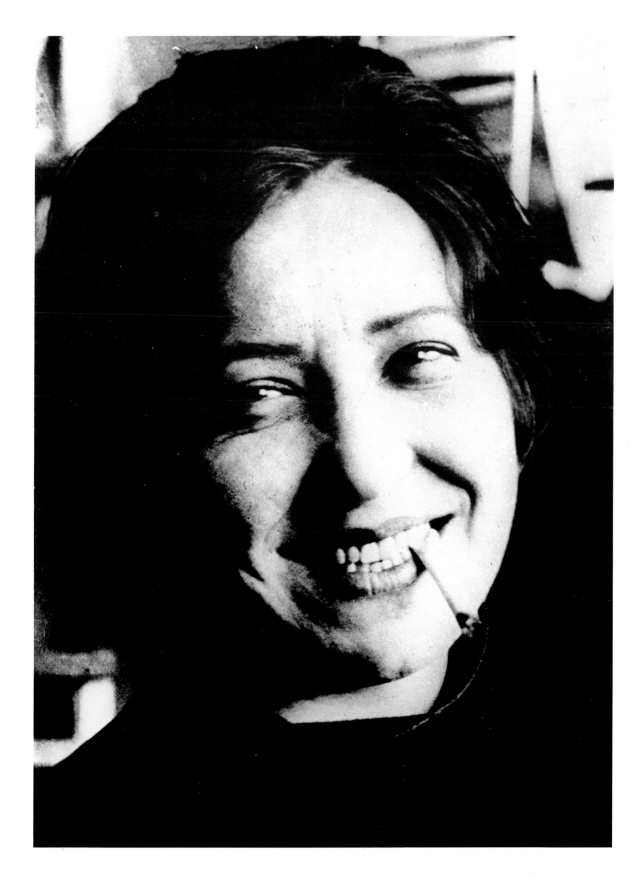

85 Portrait Varvara Stepanova, 1924
Portrait of Varvara Stepanova, 1924
Portrait de Varvara Stepanova, 1924

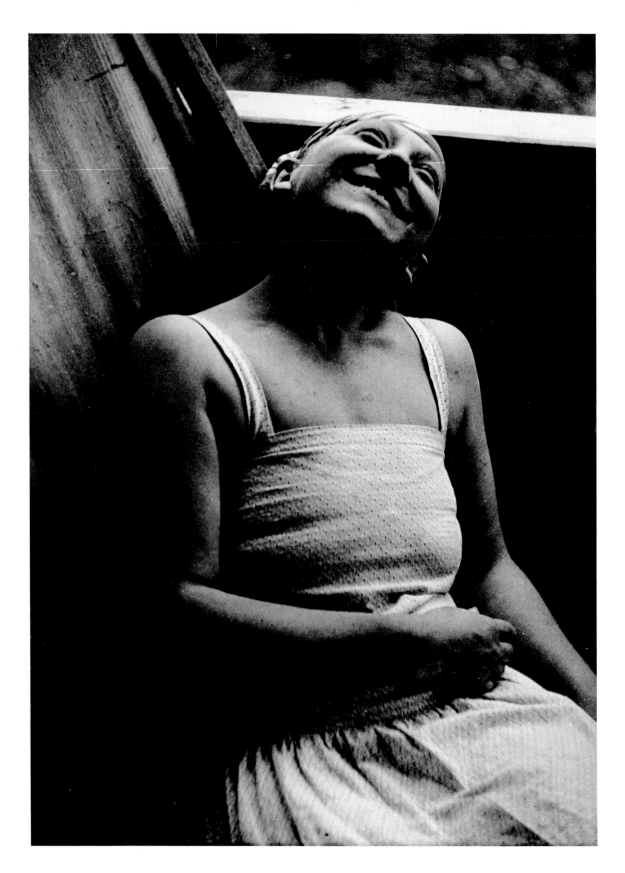

86 Portrait Varvara Stepanova, 1927
 Portrait of Varvara Stepanova, 1927
 Portrait de Varvara Stepanova, 1927

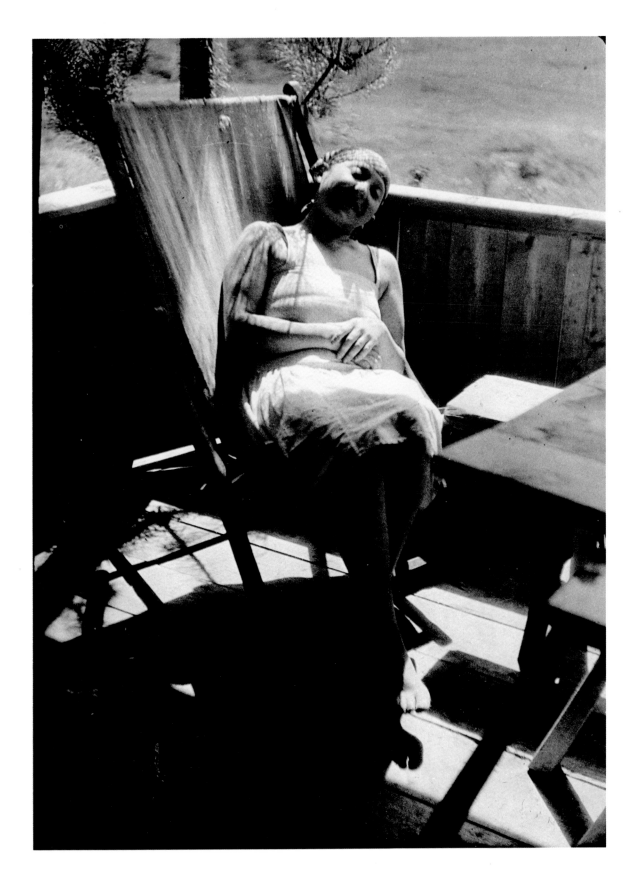

87 Portrait Varvara Stepanova, 1927
Portrait of Varvara Stepanova, 1927
Portrait de Varvara Stepanova, 1927

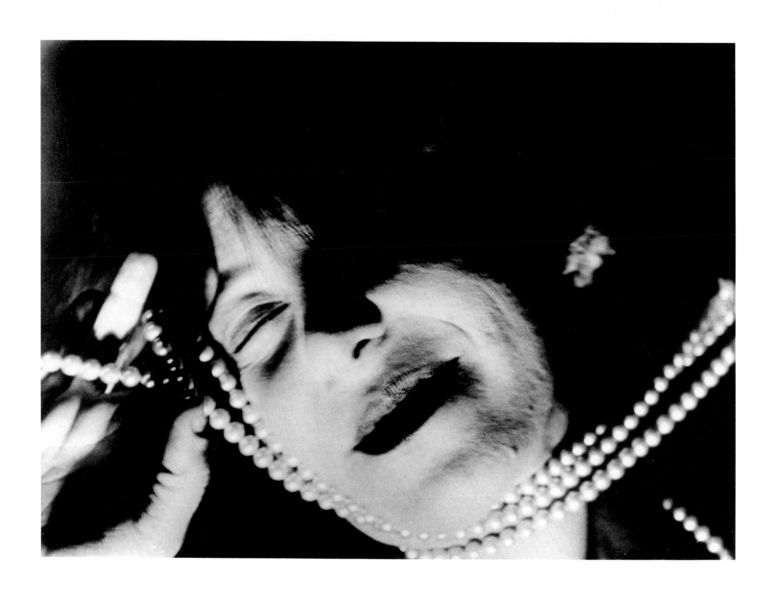

88 Portrait Varvara Stapanova, 1928
 Portrait of Varvara Stepanova, 1928
 Portrait de Varvara Stepanova, 1928

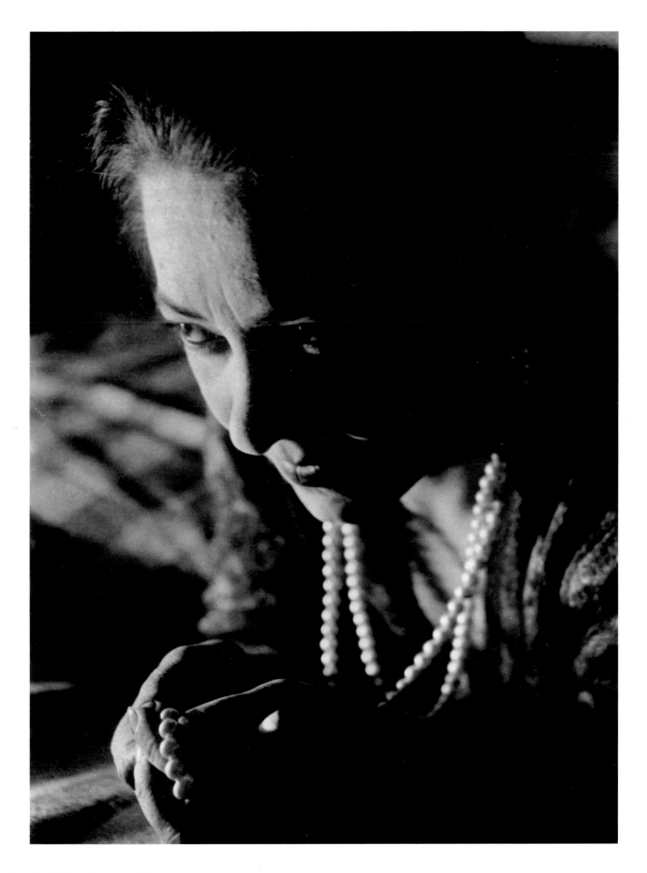

89 Portrait Varvara Stepanova, 1928
Portrait of Varvara Stepanova, 1928
Portrait de Varvara Stepanova, 1928

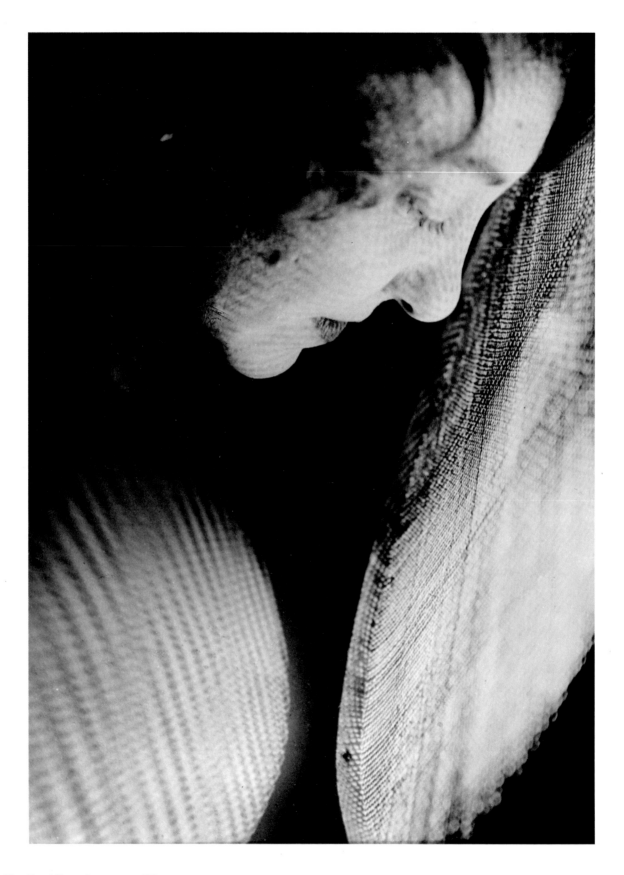

90 Portrait Varvara Stepanova, ca. 1928
Portrait of Varvara Stapanova, about 1928
Portrait de Varvara Stapanova, environ 1928

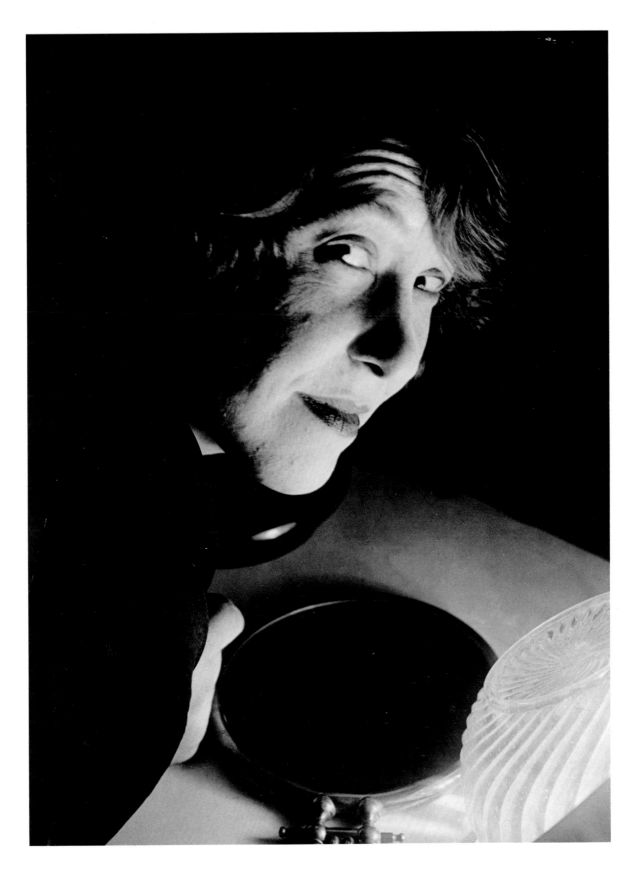

91 Portrait Varvara Stepanova, 1928
 Portrait of Varvara Stepanova, 1928
 Portrait de Varvara Stepanova, 1928

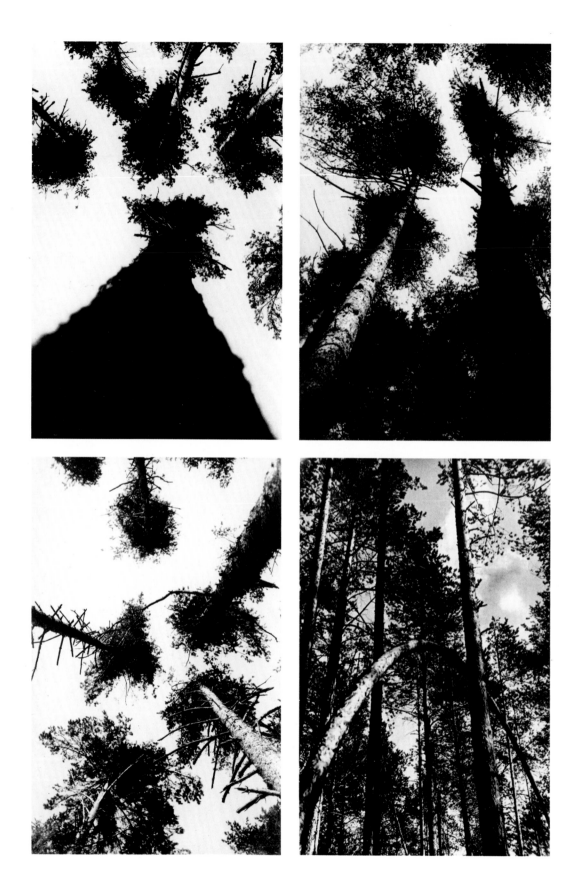

92—95 Fichten im Wald von Puškino, 1927
 Spruces in the Pushkino forest, 1927
 Epicéas dans la forêt de Puškino, 1927

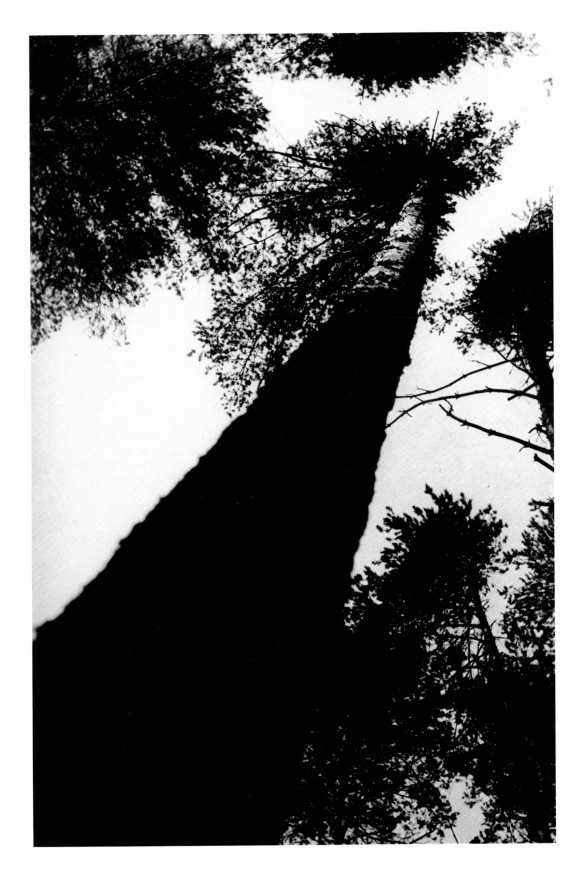

96 Fichten im Wald von Puškino, 1927
Spruces in the Pushkino forest, 1927
Epicéas dans la forêt de Puškino, 1927

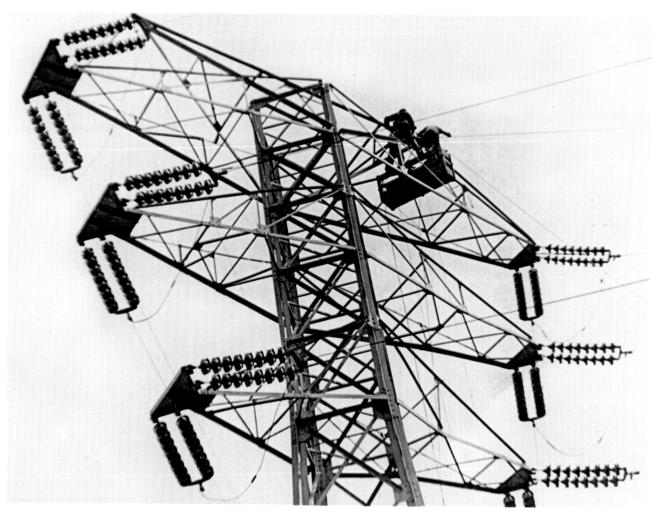

Elektroleitungsmast, 1927 97
Pylon, 1927
Pylône, 1927

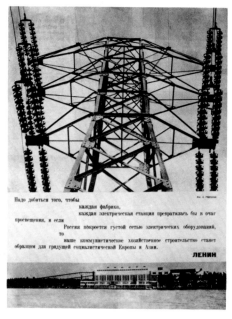

98 Umschlag der Zeitschrift NOVYJ LEF, Heft 5, 1927
Magazine cover of NOVII LEF, number 5, 1927
Couverture de la revue NOVYJ LEF, numéro 5, 1927

Seite aus der Zeitschrift DAEŠ, 1929 99
Page of the magazine DAEŠ, 1929
Page du magazine DAEŠ, 1929

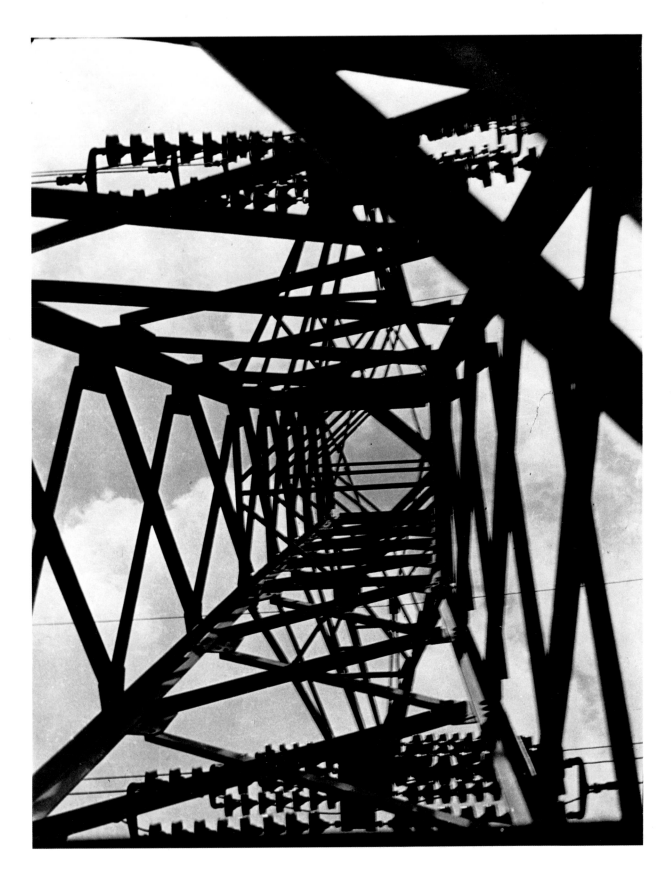

100 Elektroleitungsmast, 1927
 Pylon, 1927
 Pylône, 1927

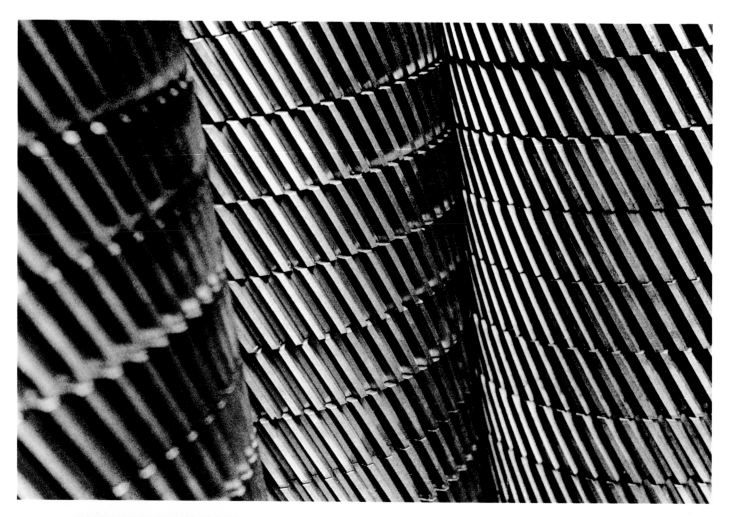

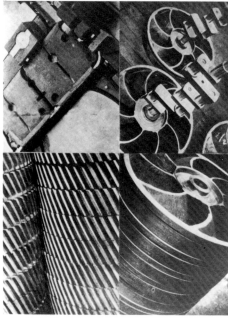

Seite aus der Zeitschrift DAEŠ, 1929
Page of the magazine DAEŠ, 1929
Page du magazine DAEŠ, 1929

Zahnräder aus der AMO-Reportage, 1929
Cog-wheels from the AMO photo-coverage, 1929
Roues dentées an reportage sur AMO, 1929

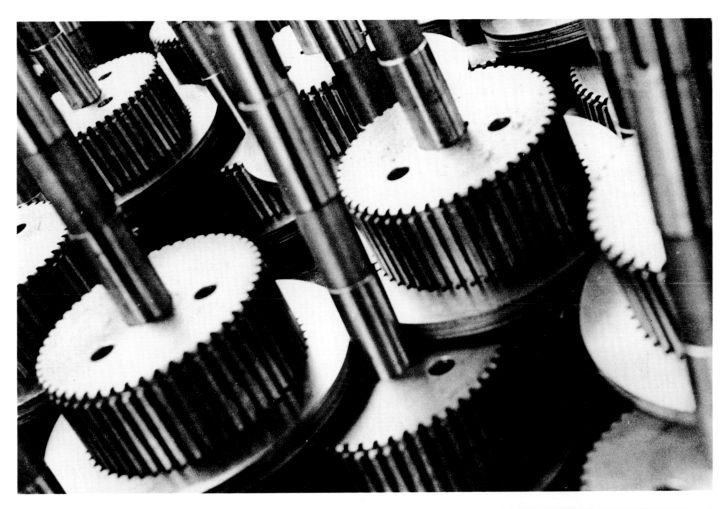

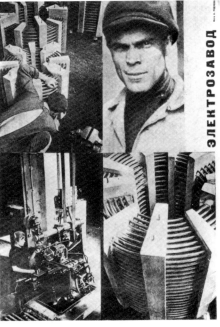

103 Zahnräder, 1929
Cog-wheels, 1929
Roues dentées, 1929

Seite aus der Zeitschrift DAEŠ: Elektrowerk, 1929 104
Page of the magazine DAEŠ: Electrical Works, 1929
Page du magazine DAEŠ: Centrale électrique, 1929

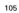

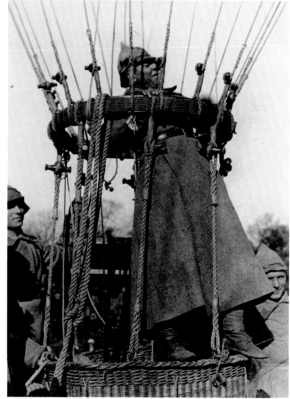

106

105 Manöver der Roten Armee, 1925
The Red Army on maneuvre, 1925
Manoeuvres de l'Armée Rouge, 1925

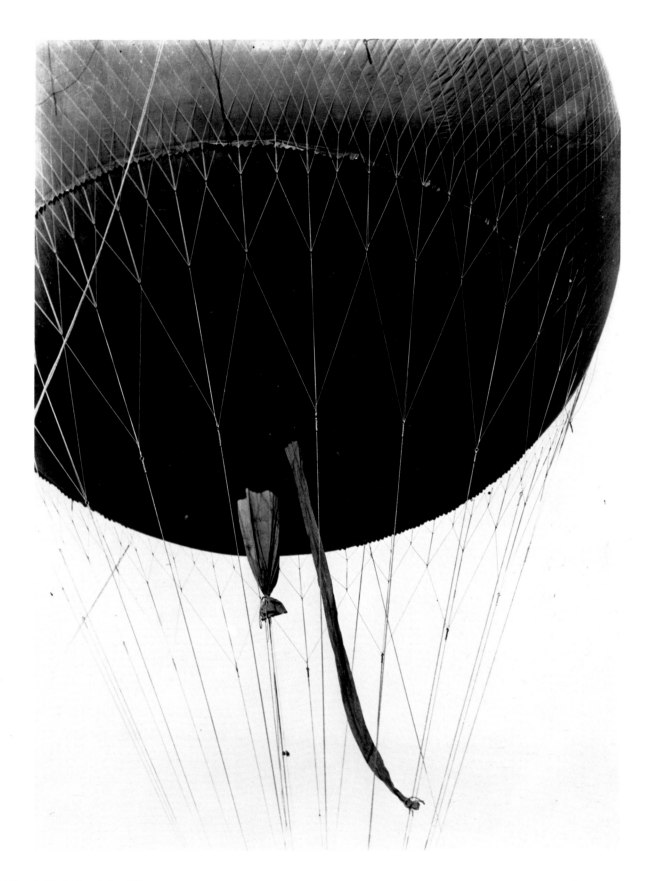

106–107 Aufstieg im Fesselballon, 1924
Ascent in an anchored balloon, 1924
Montée dans un ballon captif, 1924

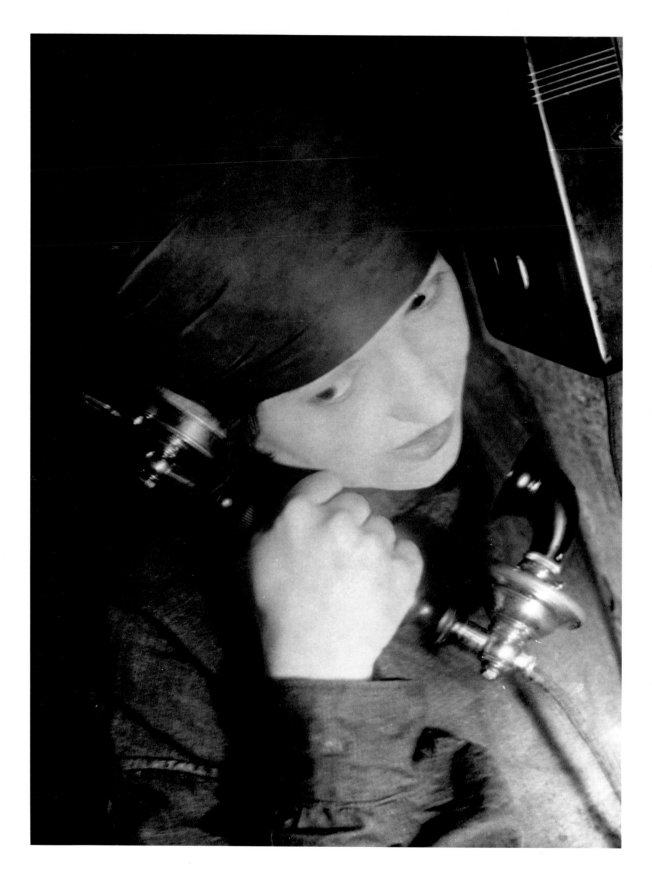

108 Kurier (aus der Reportage über eine Zeitung), 1928
Courier (from an article about a newspaper), 1928
Courrier (tiré du reportage sur un journal), 1928

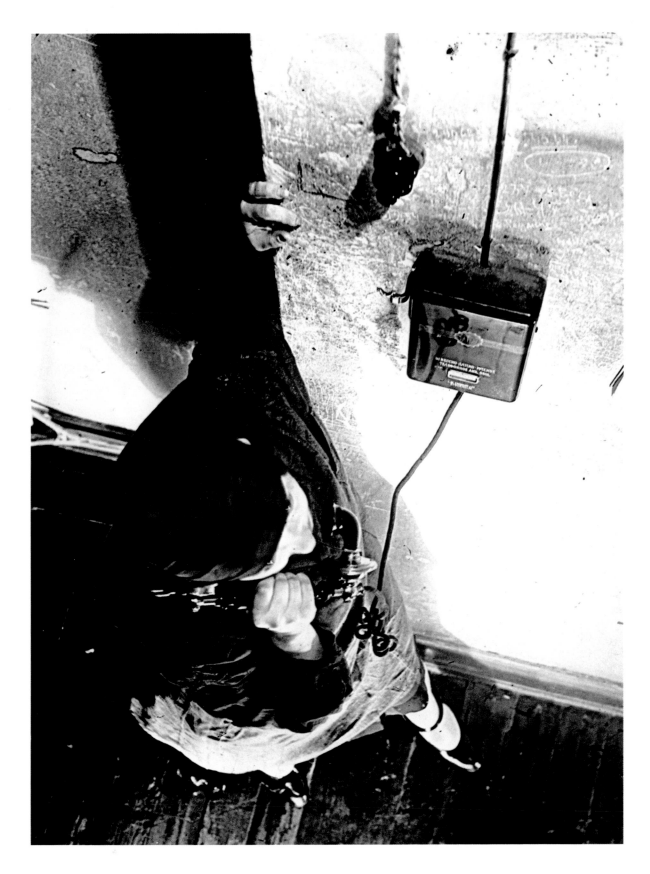

109 Kurier, 1928
Courier, 1928
Courrier, 1928

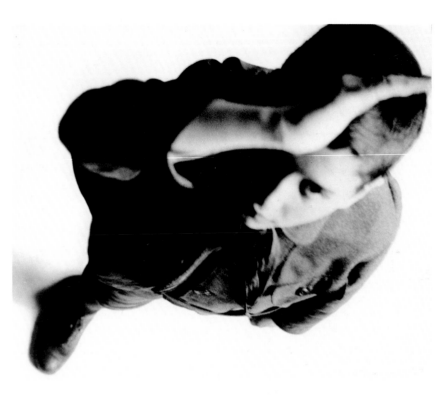

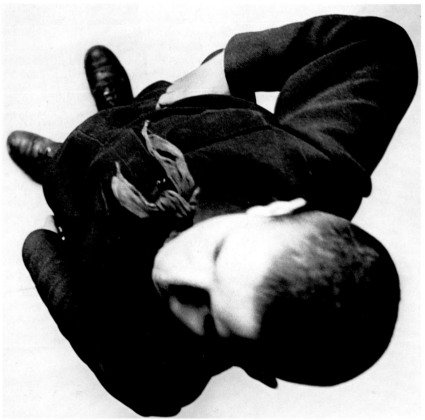

110–111 Pioniere, 1928
Pioneers, 1928
Soldats du génie, 1928

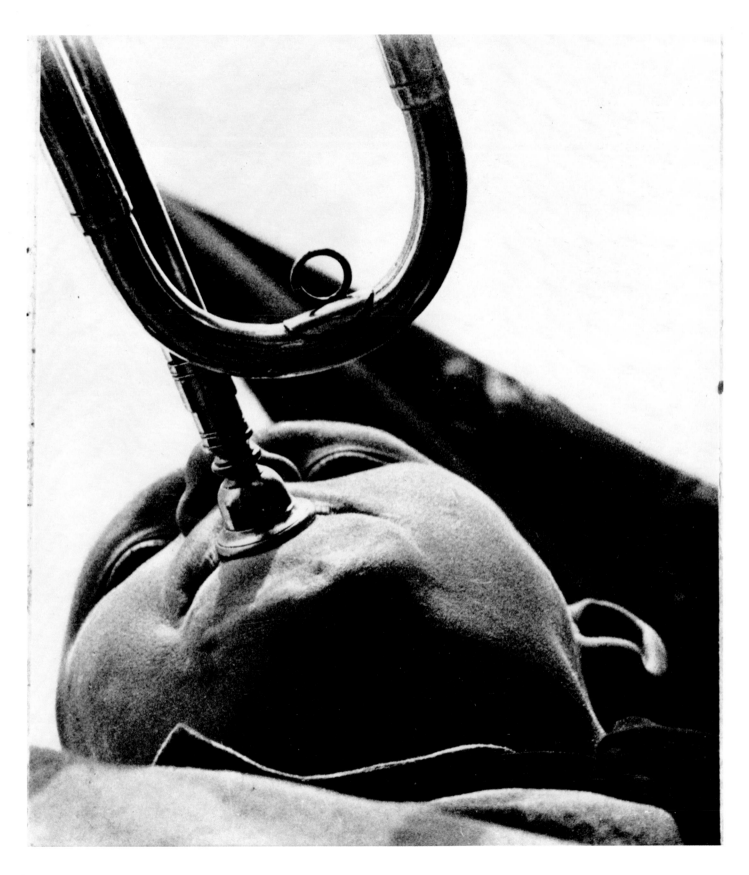

112 Pionier mit Horn, 1930
Pioneer with a horn, 1930
Soldat du génie avec cor, 1930

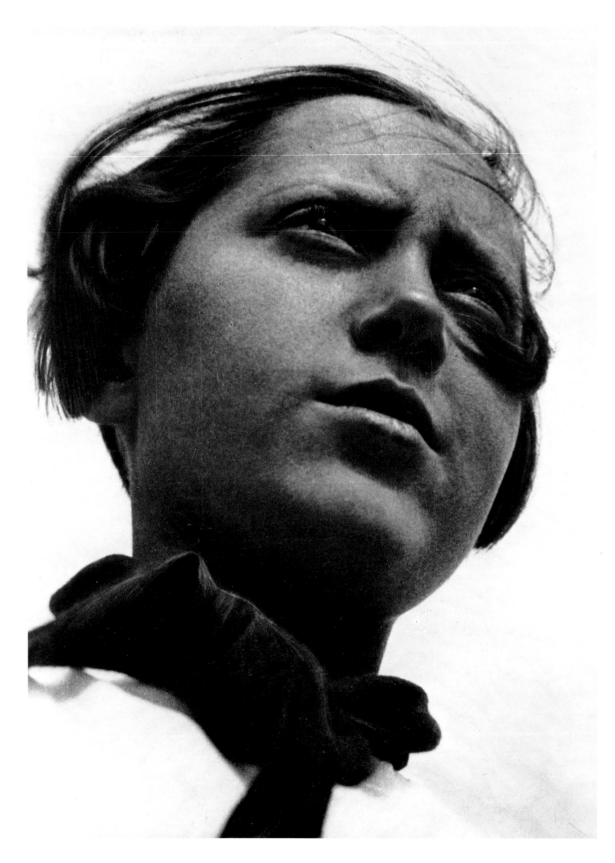

113 Pionierin, 1930
 Pioneer, 1930
 Soldat du génie, 1930

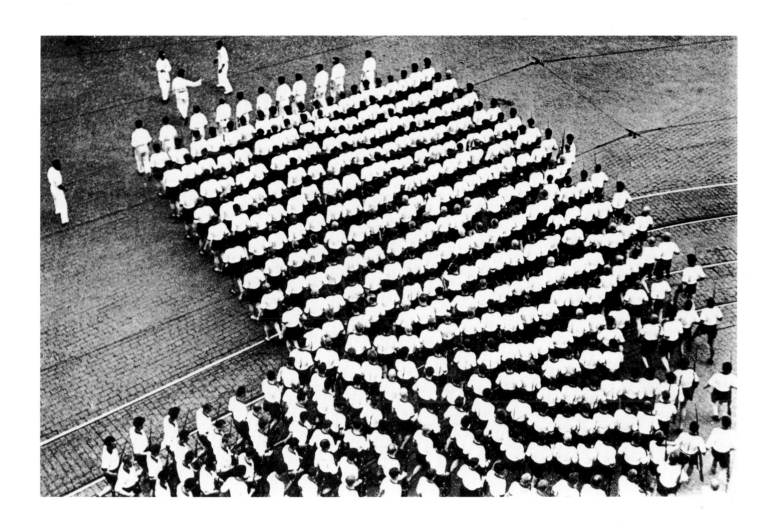

114 Dynamo – Moskau, 1930
 Dynamo – Moscow, 1930
 Dynamo – Moscou, 1930

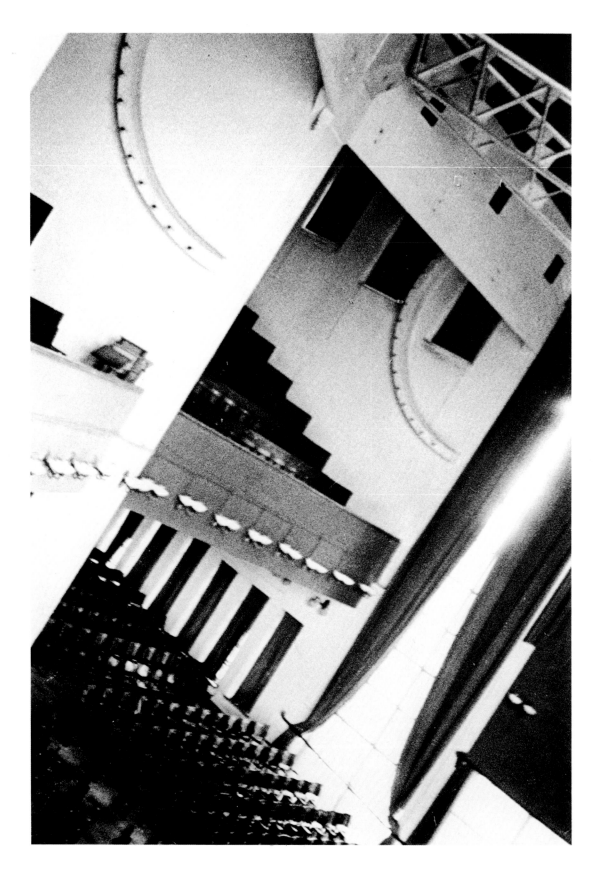

115 Arbeiterklub Rusakov (Architekt Mel'nikov), 1928
Rusakov workers' Club (Melnikov architect), 1928
Club d'ouvriers (Architecte Mel'nikov), 1928

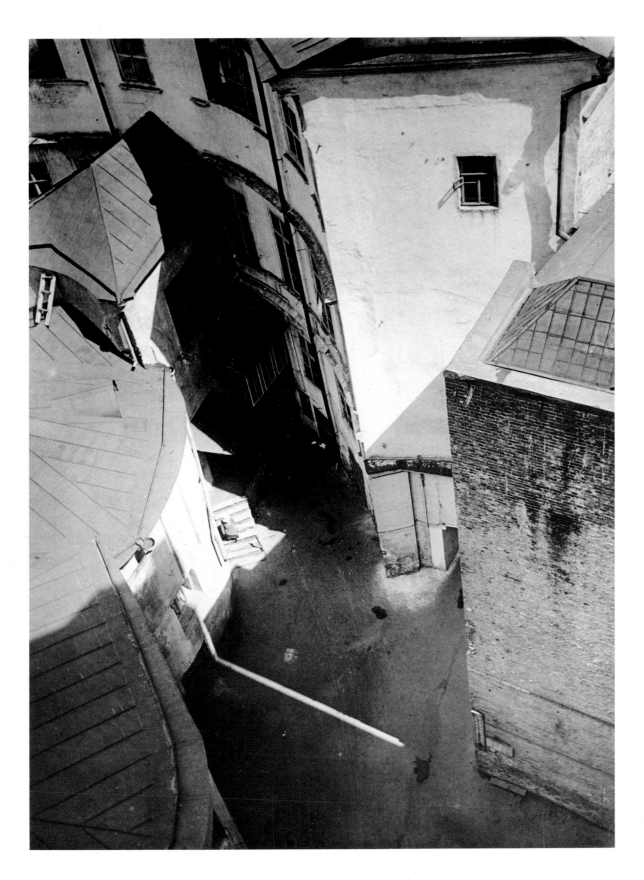

116 Hinterhof an der Mjasnicka-Straße, 1928
 Courtyard on Myasnicka-Street, 1928
 Arrière-cour Rue Mjasnicka, 1928

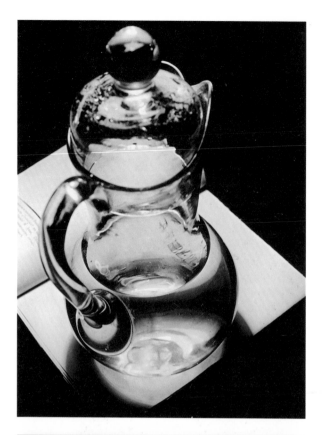

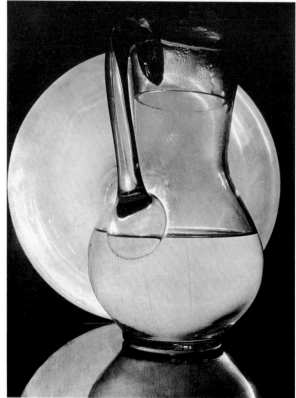

117—118 Glas im Licht, 1928
 Glass in light, 1928
 Verre dans la lumière, 1928

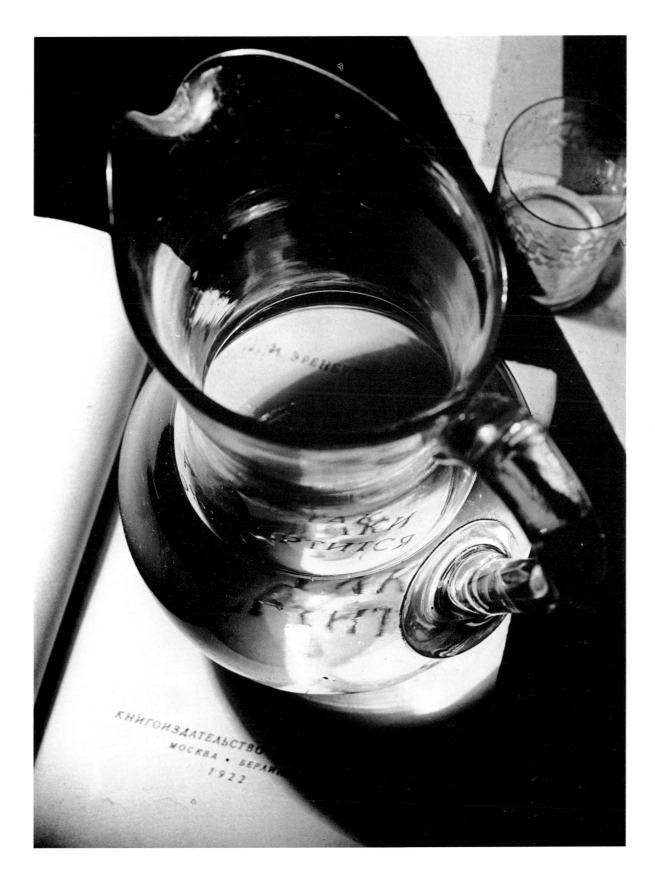

119 Glas im Licht, 1928
Glass in light, 1928
Verre dans la lumière, 1928

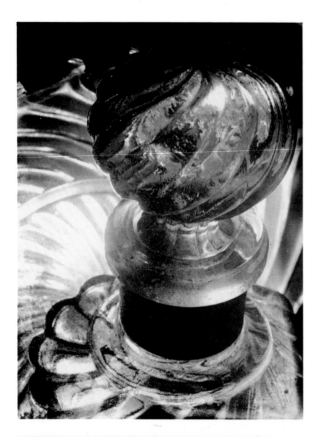

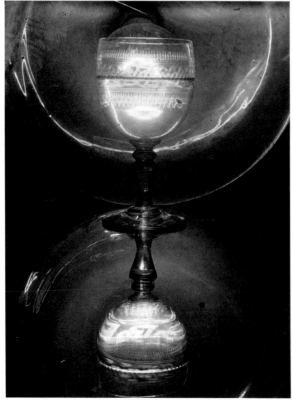

120 – 121 Glas im Licht, 1928
Glass in light, 1928
Verre dans la lumiére, 1928

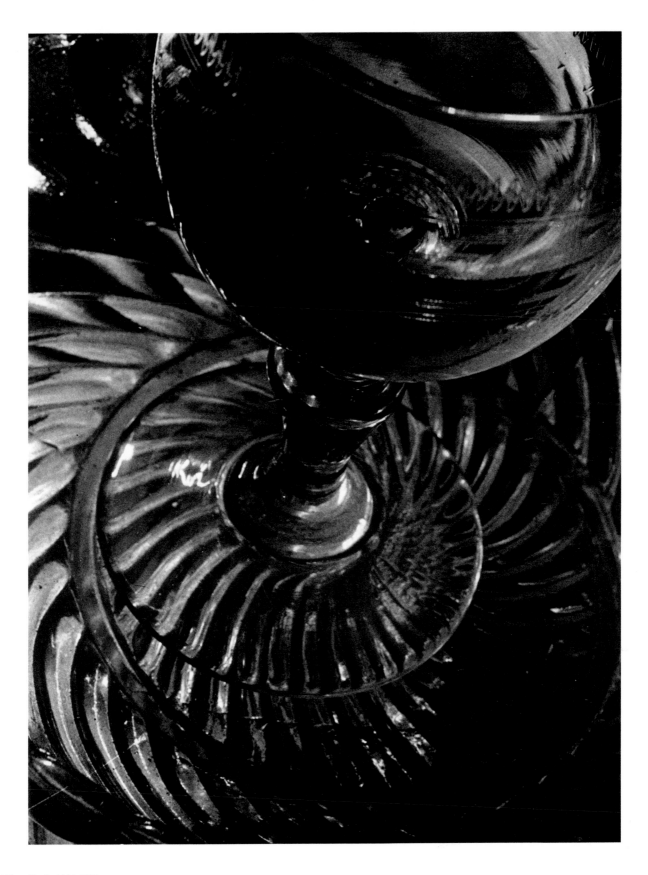

122 Glas im Licht, 1928
 Glass in light, 1928
 Verre dans la lumière, 1928

123 Asphaltieren einer Straße in Moskau, 1929
Asphalting a street in Moscow, 1929
Bitumage d'une rue de Moscou, 1929

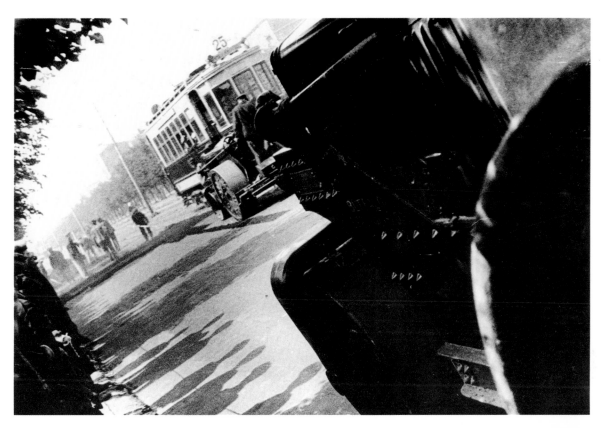

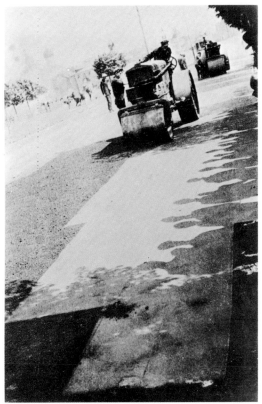

124—125 Asphaltieren einer Straße in Moskau, 1929
Asphalting a street in Moscow, 1929
Bitumage d'une rue de Moscou, 1929

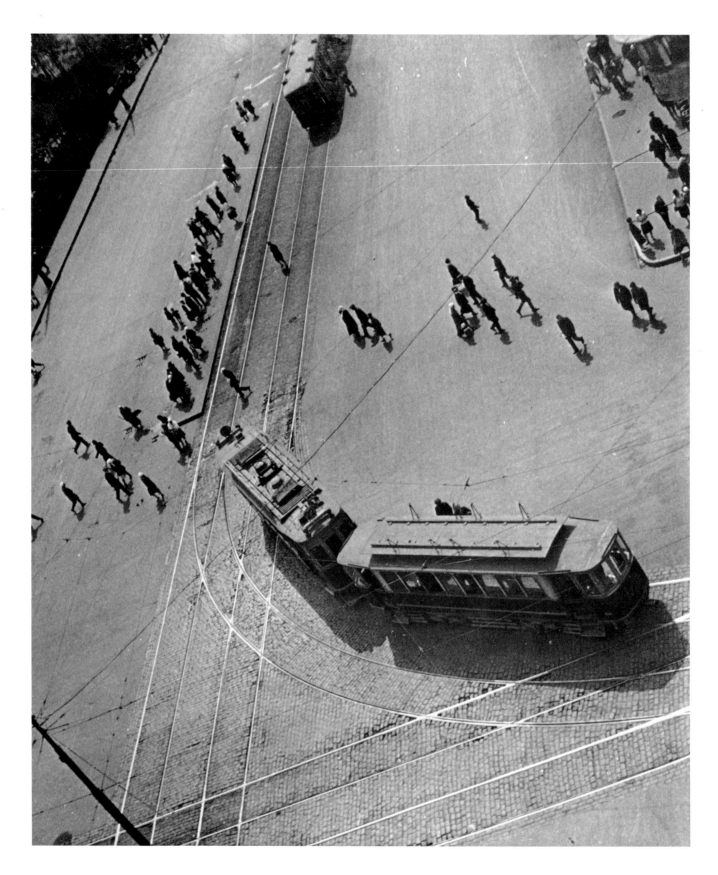

126 Ein Stück Moskau, 1927
 A part of Moscow, 1927
 Coin de Moscou, 1927

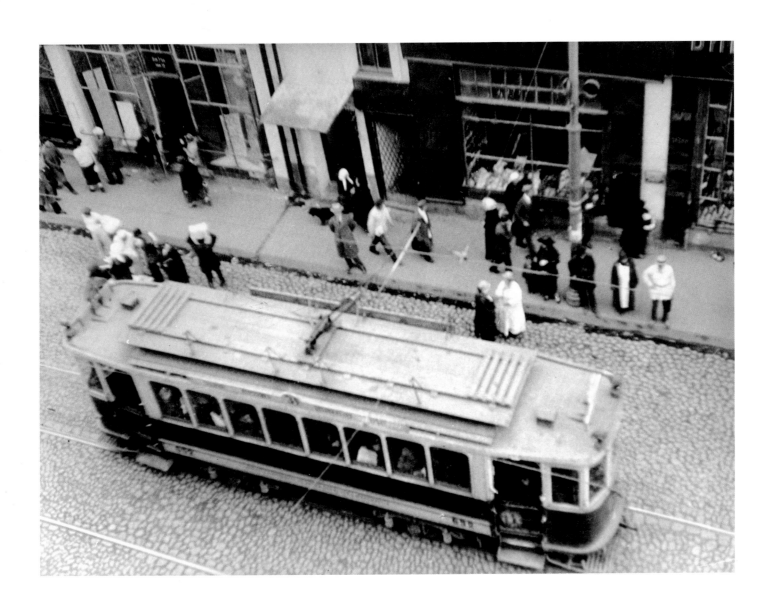

127 Straße in Moskau, 1929
Street in Moscow, 1929
Rue de Moscou, 1929

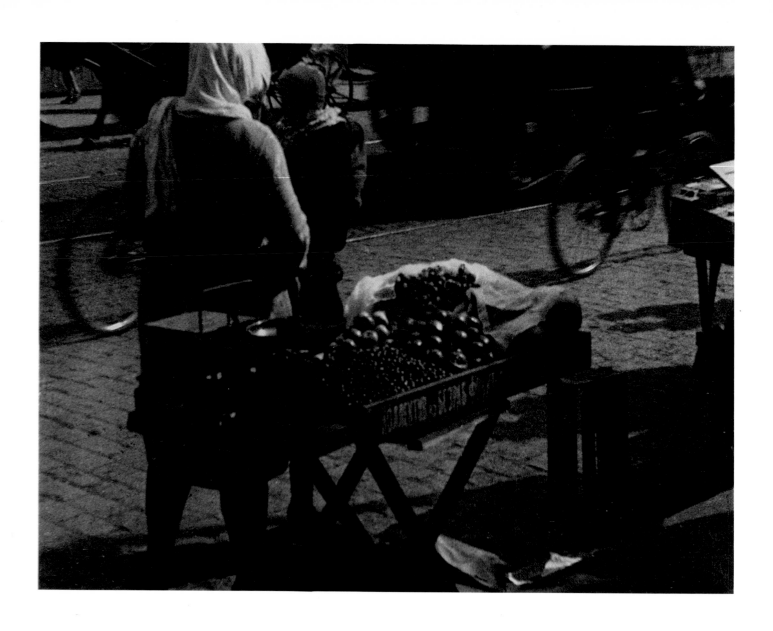

128 Straßenhandel, 1925
Street vendors, 1925
Commerce ambulant, 1925

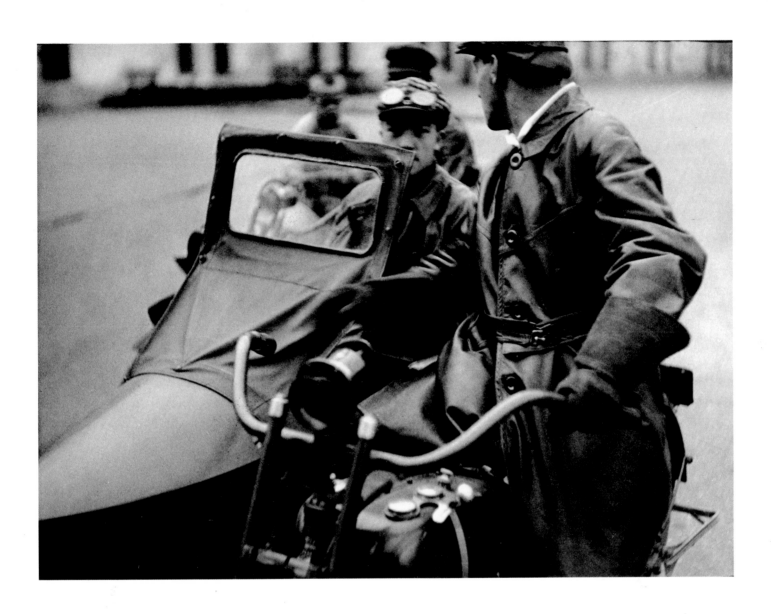

129 Auf den Straßen von Moskau, 1926
On the streets of Moscow, 1926
Dans les rues de Moskou, 1926

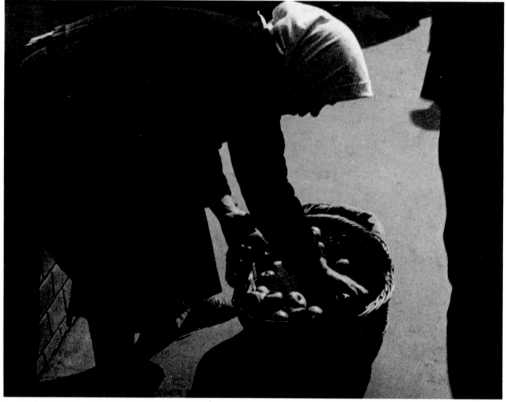

130—131 Straßenhandel, 1925
Street vendors, 1925
Commerce ambulant, 1925

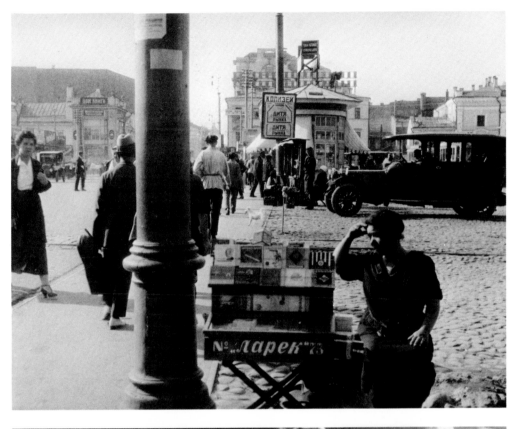

132

133

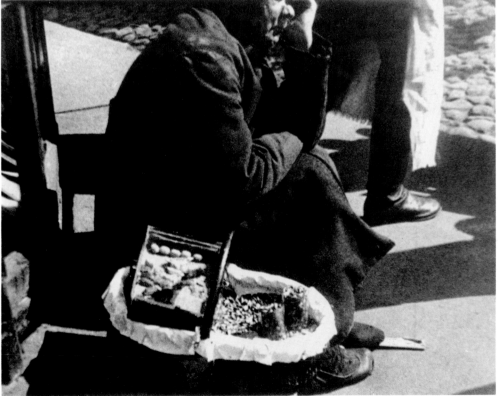

132 Auf den Straßen von Moskau, 1927 Straßenhandel, 1925 133
 On the streets of Moscow, 1927 Street vendors, 1925
 Dans le rues de Moscou, 1927 Commerce ambulant, 1925

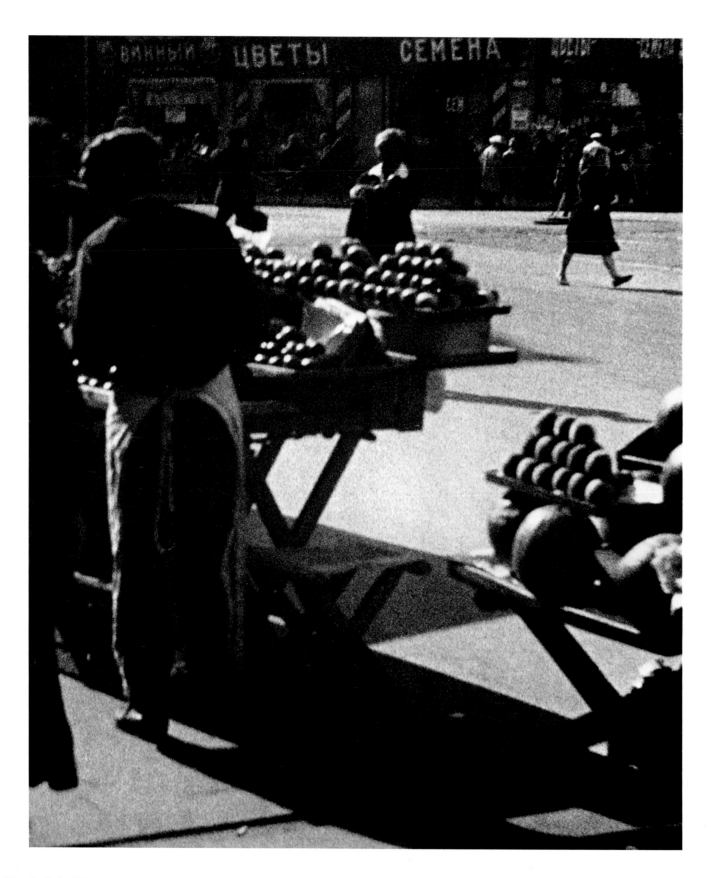

134 Straßenhandel, 1925
Street vendors, 1925
Commerce ambulant, 1925

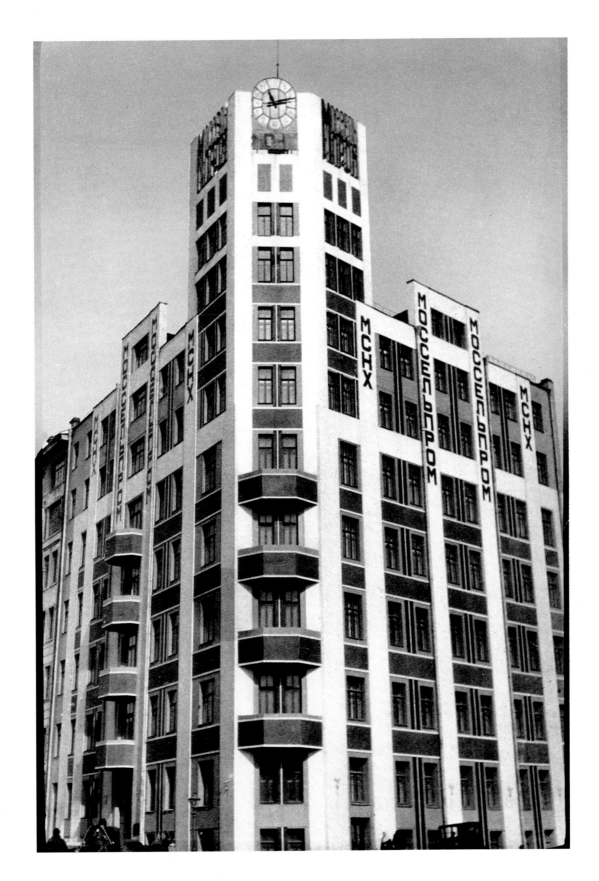

135 Haus Mosselprom (Moskauer Staatstrust zur Verarbeitung landwirtschaftlicher Produkte), 1926
 Mosselprom House (Moscow State Trust for the processing of agricultural products), 1926
 Maison Mosselprom (Trust d'état de Moscou pour la transformation des produits agricoles), 1926

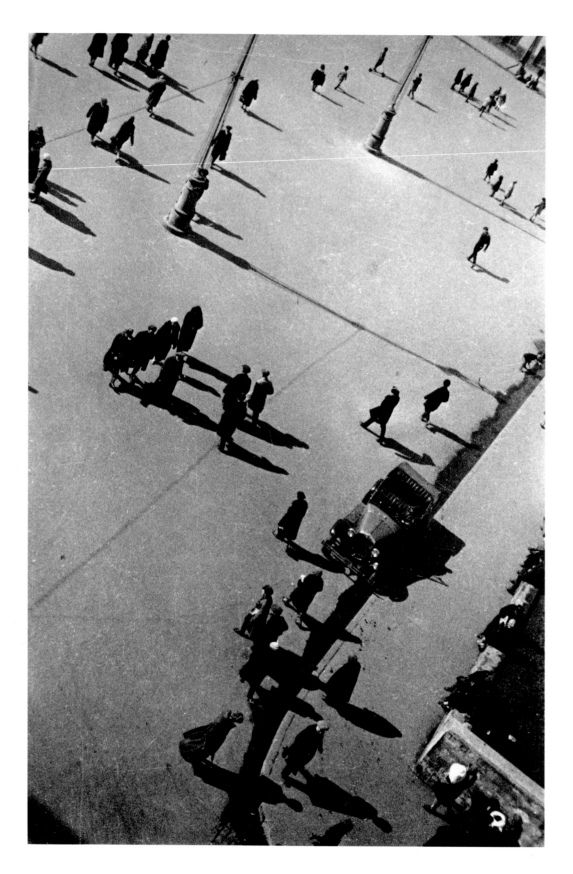

136 Straße in Moskau, ca. 1930
 A street in Moscow, about 1930
 Rue de Moscou, environ 1930

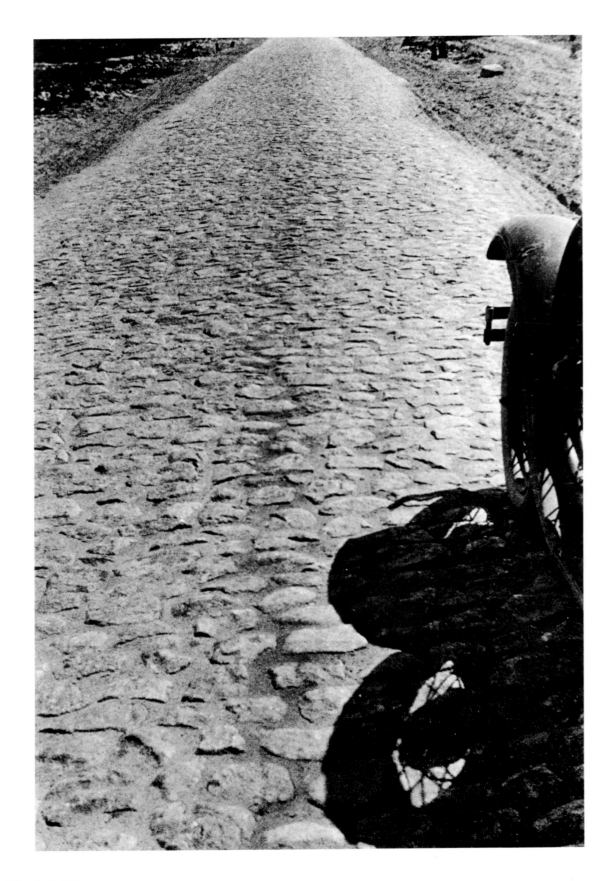

137 Straße, 1933
 Street, 1933
 Rue, 1933

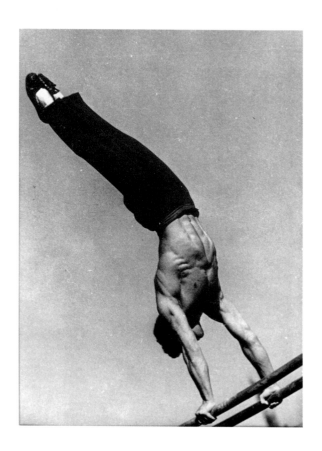

138 Am Barren, 1938
On the bars, 1938
Aux barres parallèles, 1938

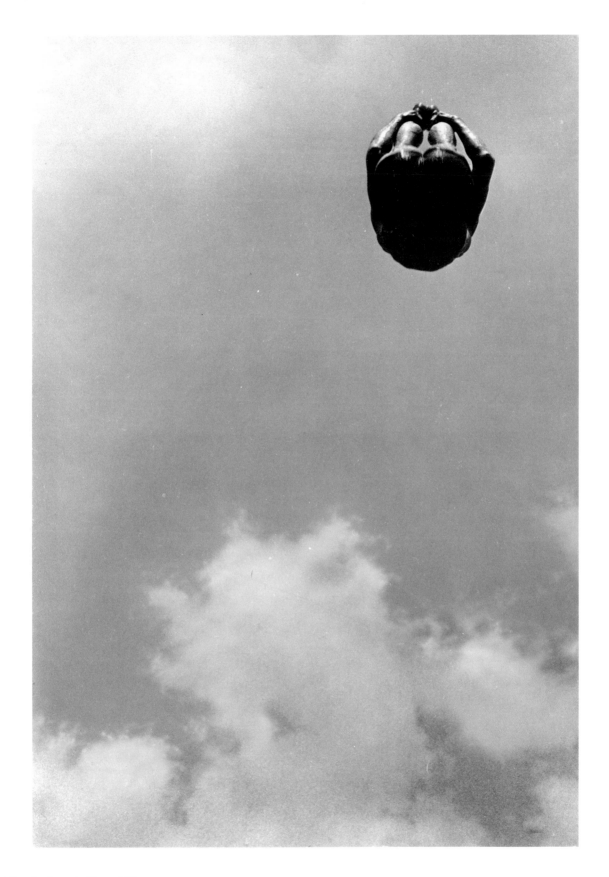

139 Der Sprung ins Wasser, 1932
The plunge, 1932
Le plongeon, 1932

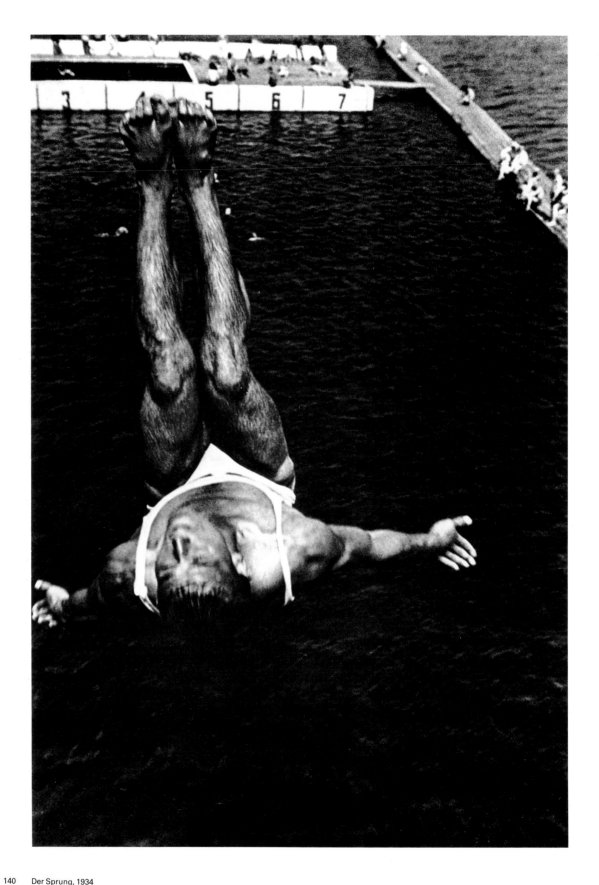

140 Der Sprung, 1934
The jump, 1934
Le saut, 1934

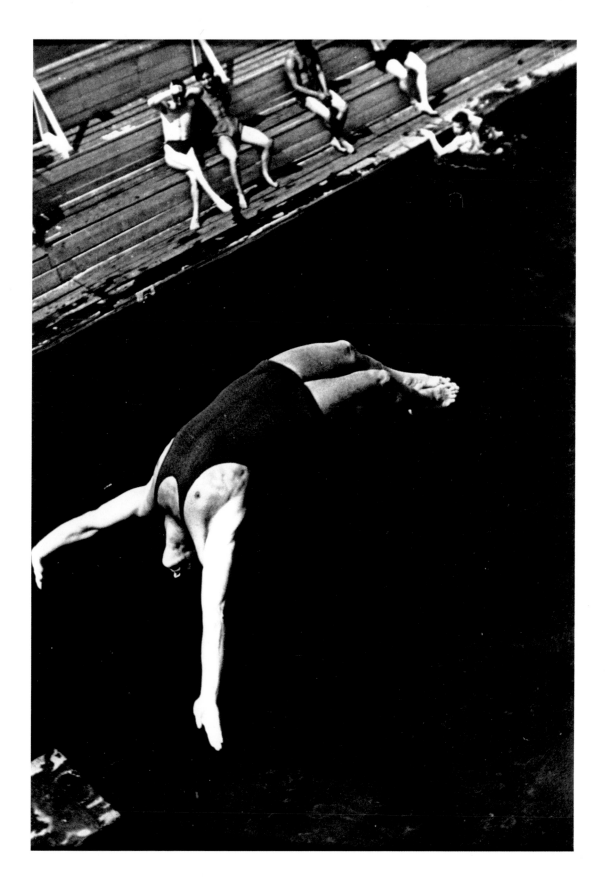

141 Der Sprung ins Wasser, ca. 1935
The plunge, about 1935
Le plongeon, environ 1935

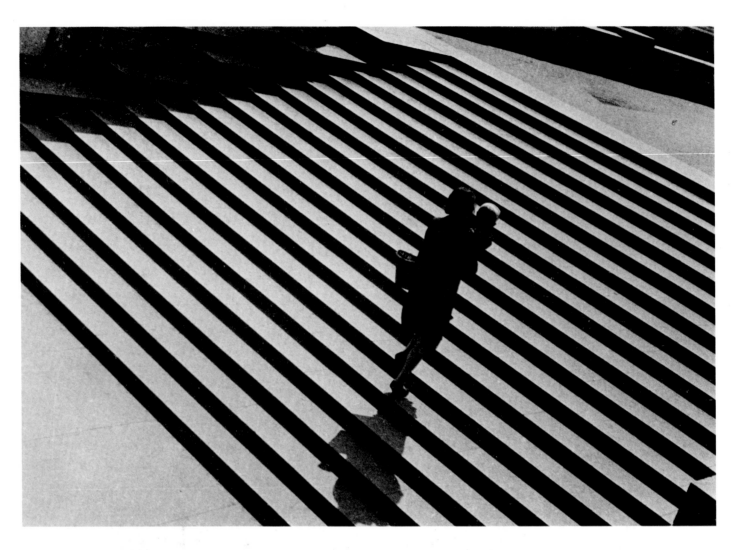

Seite aus der Zeitschrift DAEŠ, 1929
Page of the magazine DAEŠ, 1929
Page du magazine DAEŠ, 1939

Die Treppe, 1929
The stairs, 1929
L'escalier, 1929

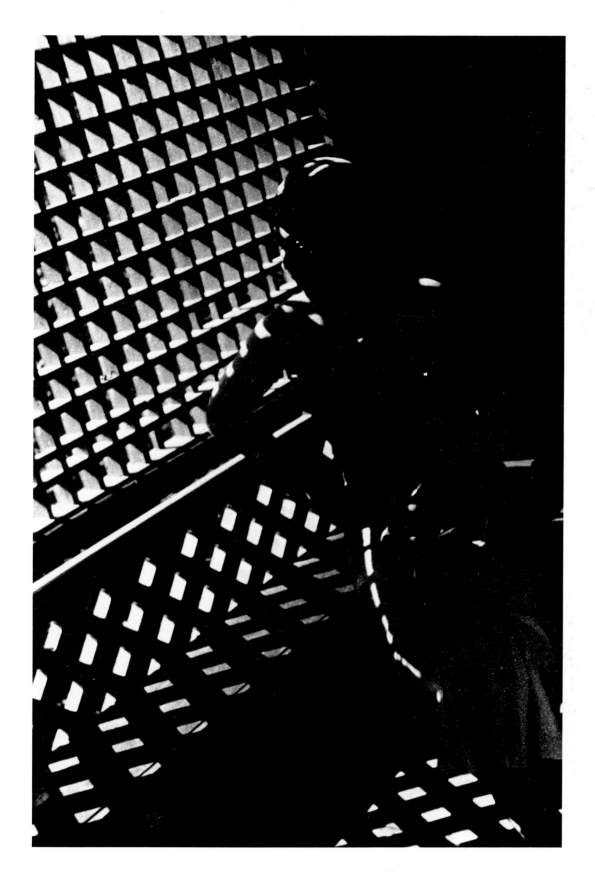

144 Frau mit Leica, 1934
 Woman with Leica, 1934
 Femme avec Leica, 1934

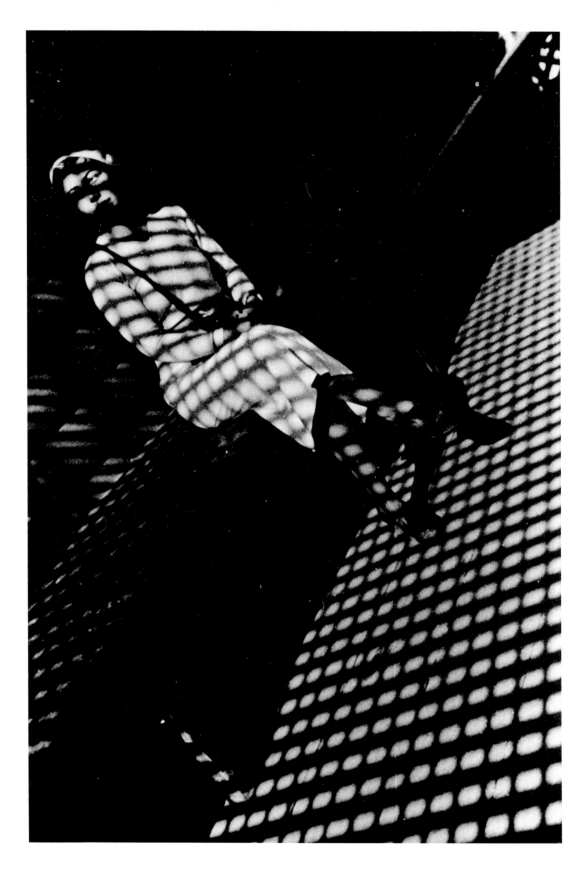

145 Frau mit Leica, 1934
 Woman with Leica, 1934
 Femme avec Leica, 1934

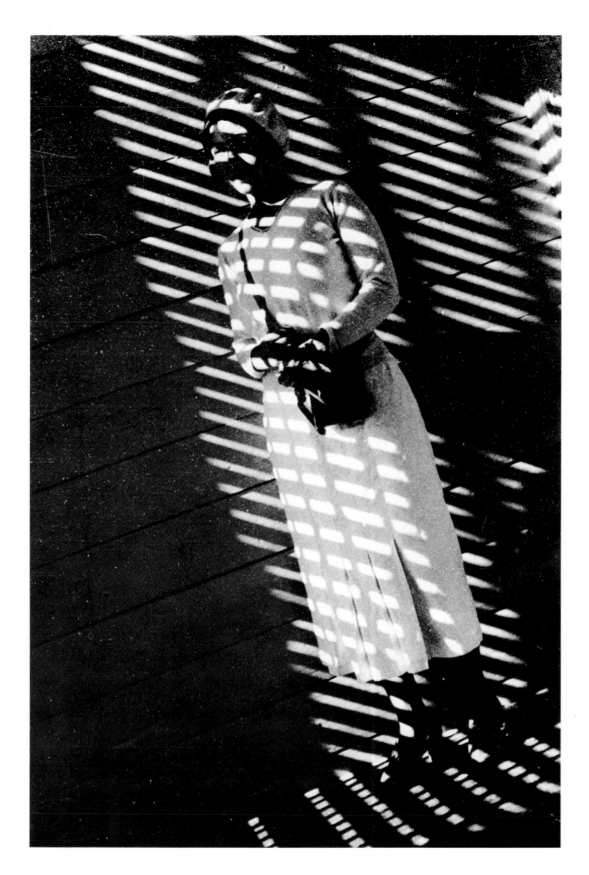

146 Frau mit Leica, 1934
Woman with Leica, 1934
Femme avec Leica, 1934

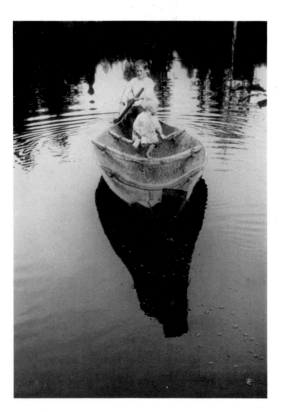

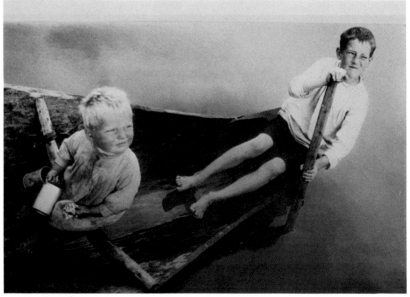

147　Auf Würmerfang, 1933
Catching worms, 1933
Attrapant des vers, 1933

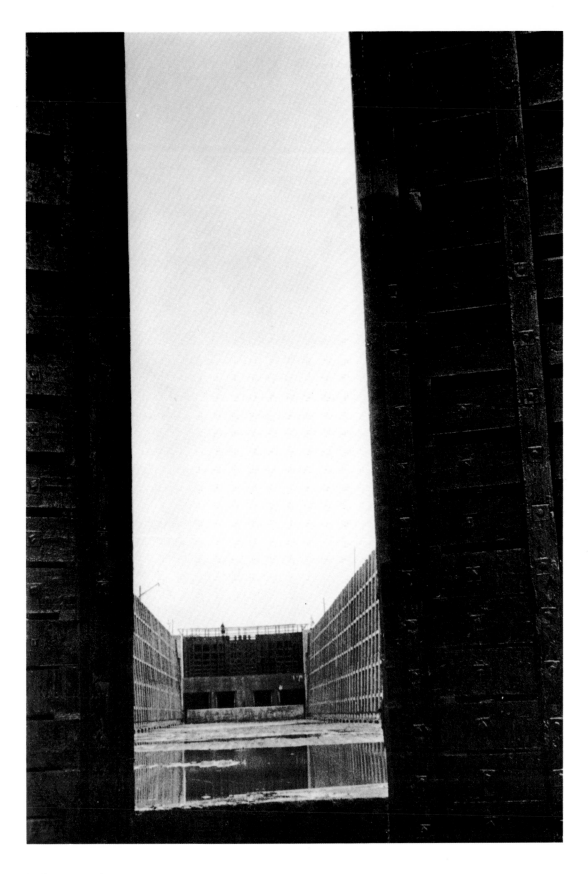

148 Das Schleusentor, 1933
The lock, 1933
La porte de l'écluse, 1933

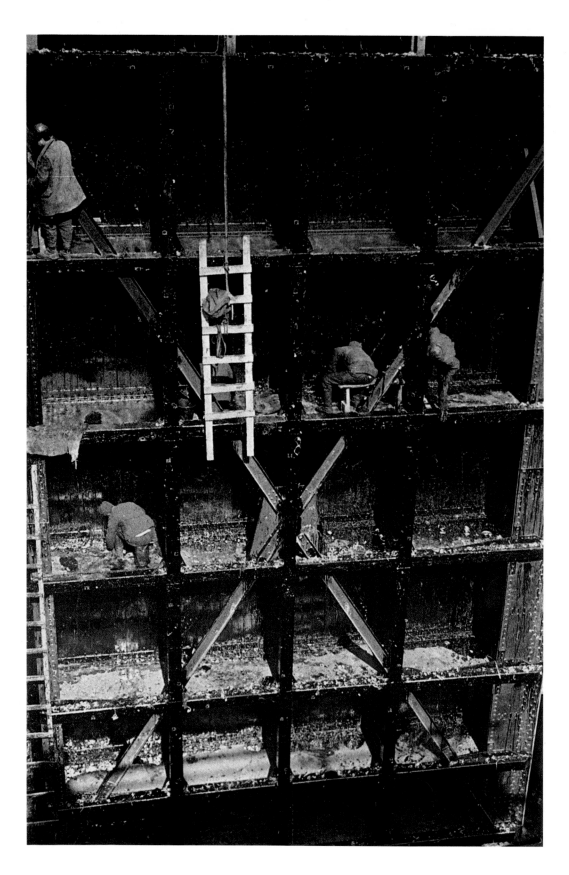

149 Beim Bau der Schleuse, 1933
 Construction of a lock, 1933
 Pendant la construction de l'écluse, 1933

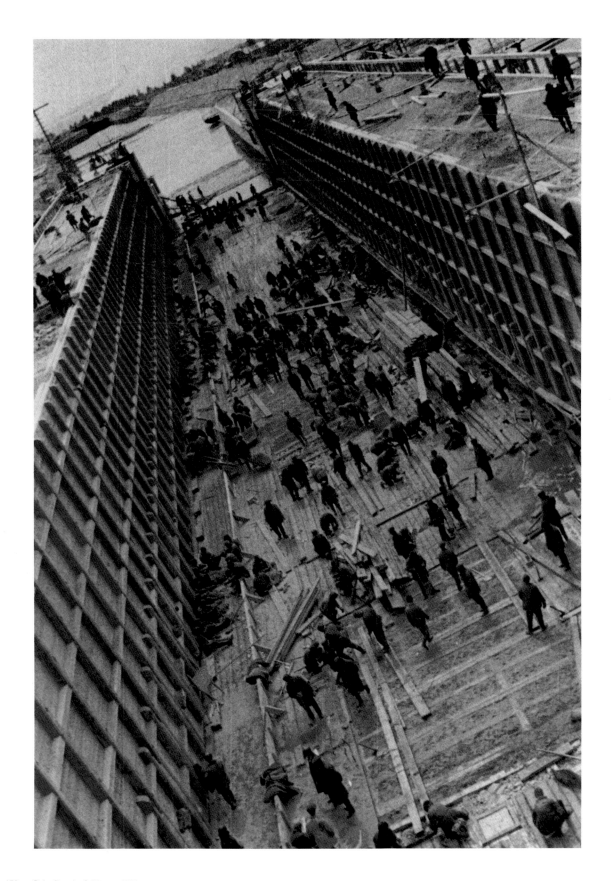

150 Beim Bau der Schleuse, 1933
Construction of a lock, 1933
Pendant la construction de l'écluse, 1933

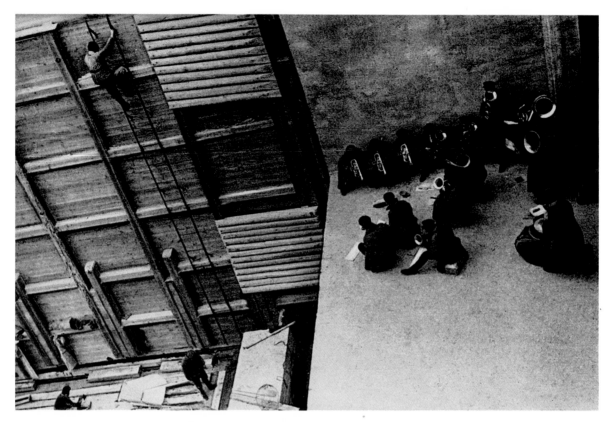

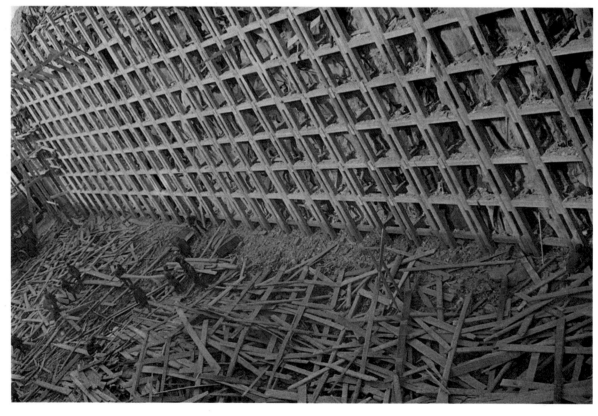

Konzert während der Arbeitspause, 1933
Concert during the work break, 1933
Concert pendant la pause de travail, 1933

Der Bau der Schleuse, 1933
The construction of the lock, 1933
La construction de l'écluse, 1933

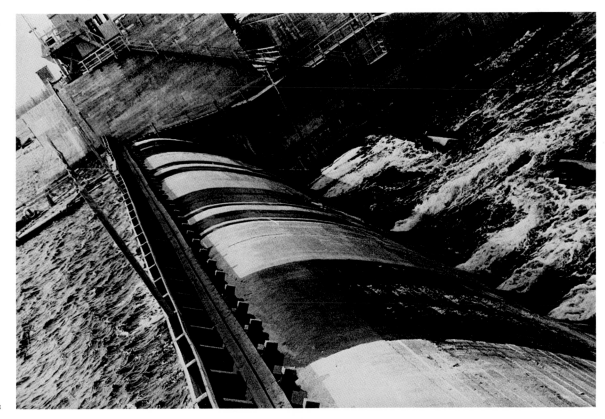

153

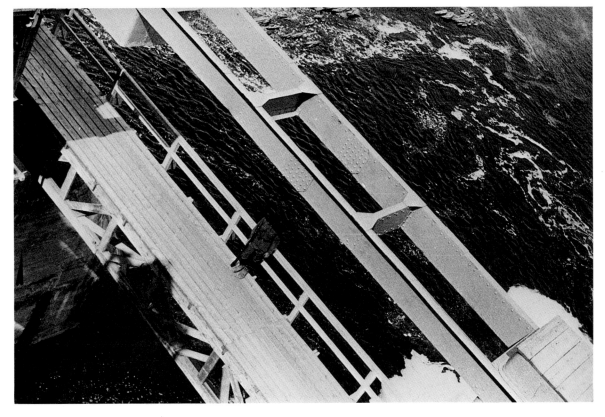

154

Der Damm, 1933
The dam, 1933
Le barrage, 1933

Wächter an der Schleuse, 1933
Guard at the lock, 1933
Gardien de l'écluse, 1933

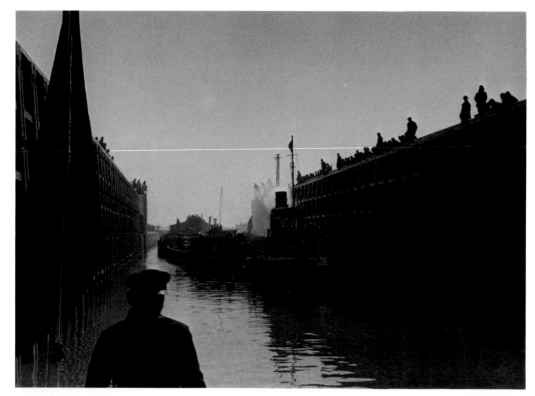

155

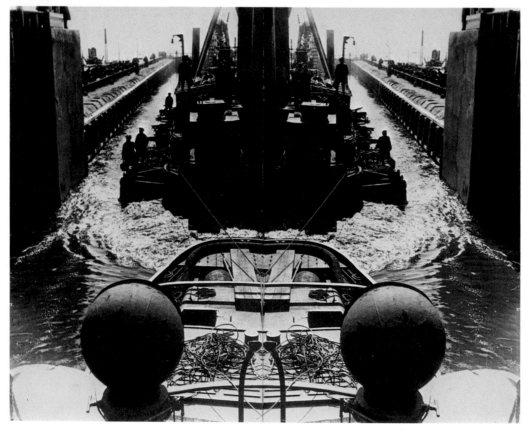

156

155 Fahrt durch die Schleuse, 1933
 Passing through the lock, 1933
 Traversée de l' écluse, 1933

Lastkähne fahren in die Schleuse, 1933 156
Barges passing through the lock, 1933
Chalands traversent l'écluse, 1933

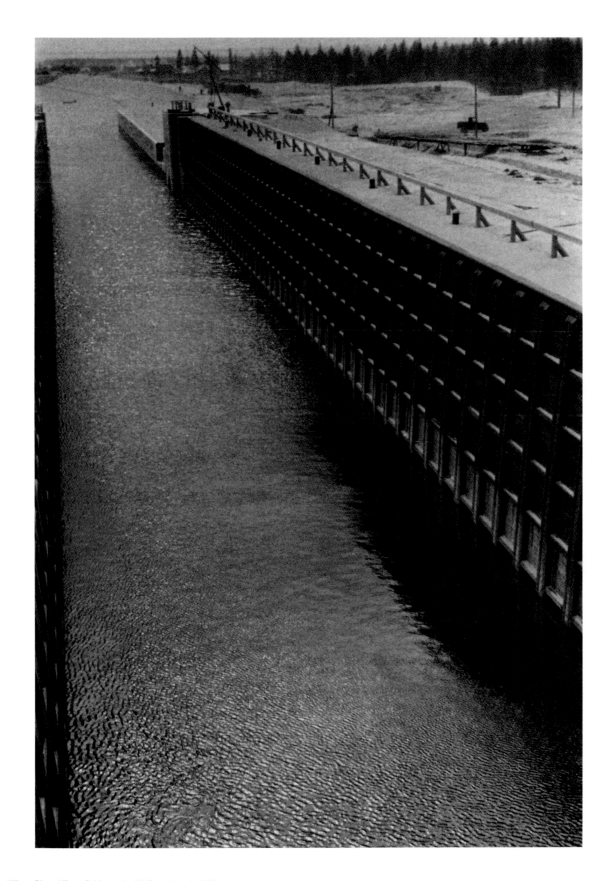

157 Die geöffnete Schleuse des Weißmeerkanals, 1933
 White Sea Canal open lock, 1933
 L'écluse du Canal de La Mer Blanche ouverte, 1933

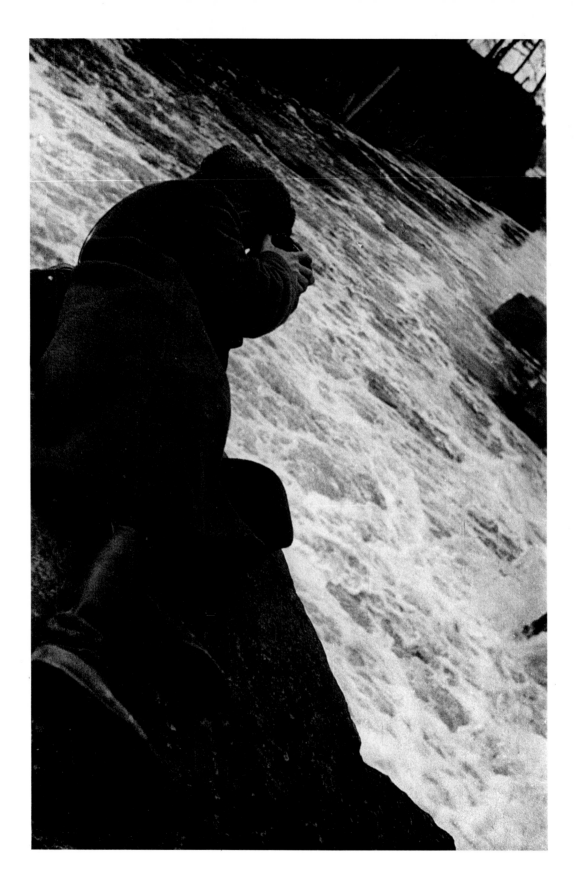

158 Beim Fotografieren (vermutlich Rodčenko), 1933
 Taking pictures (presumably Rodchenko), 1933
 En photographiant (probablement Rodčenko), 1933

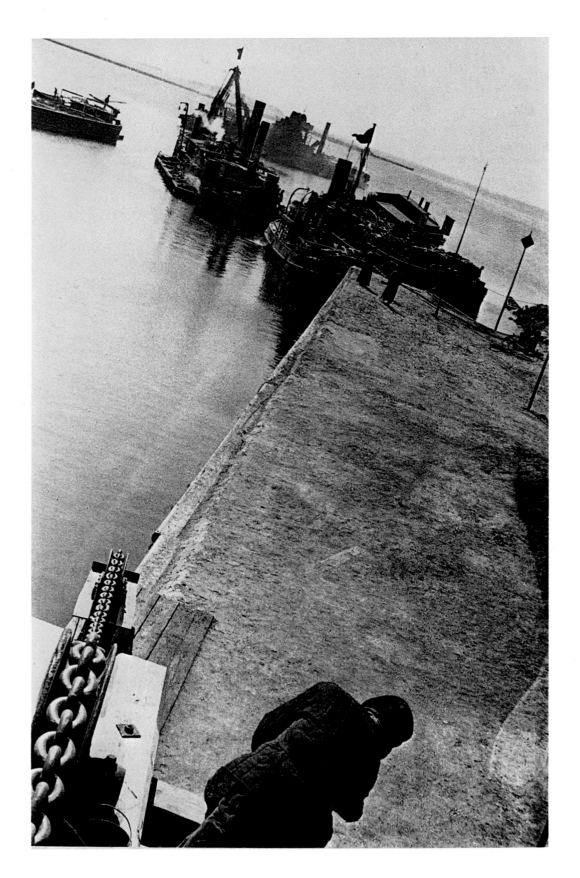

159 Der Weißmeerkanal, 1933
White Sea Canal, 1933
Le Canal de La Mer Blanche, 1933